Enchanting
HONG KONG

MARTIN WILLIAMS

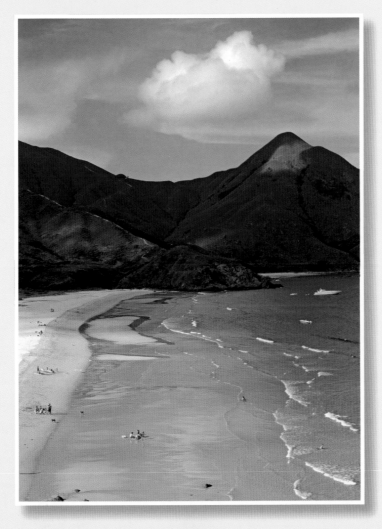

JOHN BEAUFOY PUBLISHING

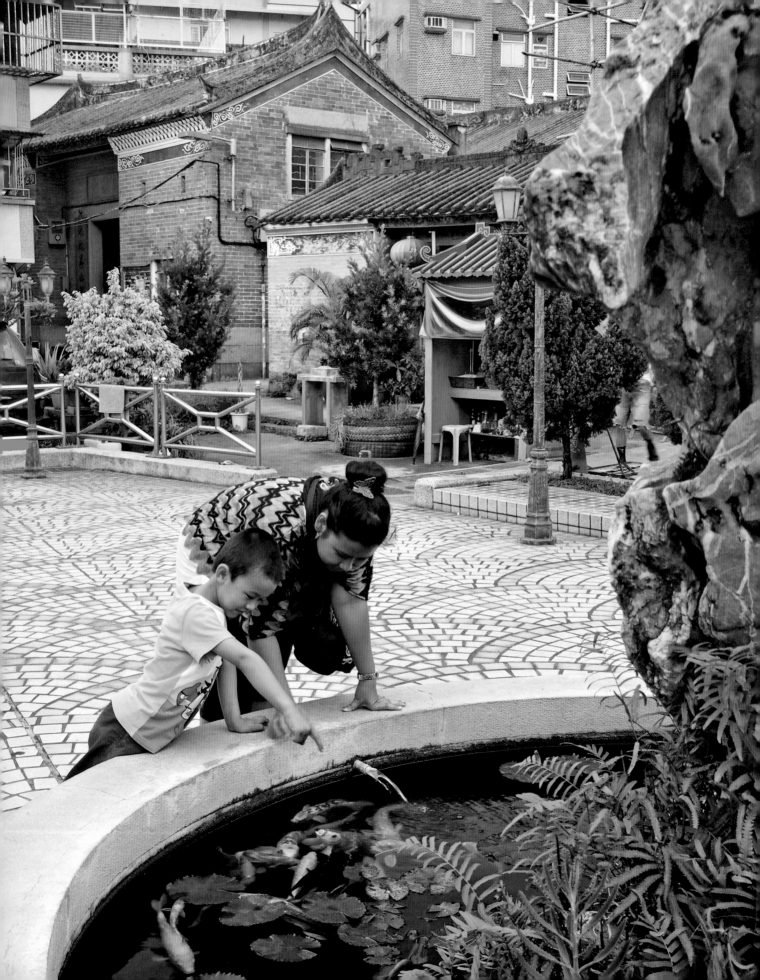

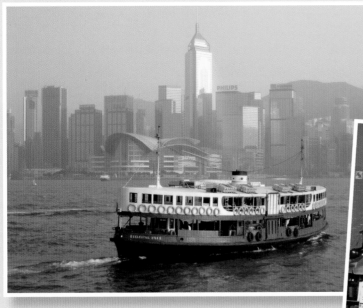

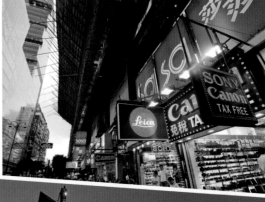

Contents

Above: A misty spring evening on the Tsim Sha Tsui waterfront.

Above left: A Star Ferry crossing Victoria Harbour, bound for Hong Kong Island.

Above right: Stores and high-rises cram Nathan Road, a key Kowloon thoroughfare.

Opposite: Goldfish spotting outside Hung Shing Temple, at Ping Shan in the northwest New Territories.

Title page: Tai Wan, the longest beach at Tai Long Wan on the Sai Kung Peninsula.

Chapter 1: Metropolis in a Natural Setting

Hong Kong is a bustling, modern metropolis packed with skyscrapers. Formerly a British colony that was founded on trade, it became a magnet for immigrants and a hub for entrepreneurs and small-scale manufacturing, then in 1997 it returned to Chinese rule as a partly autonomous financial services powerhouse, dubbed by its government 'Asia's World City'.

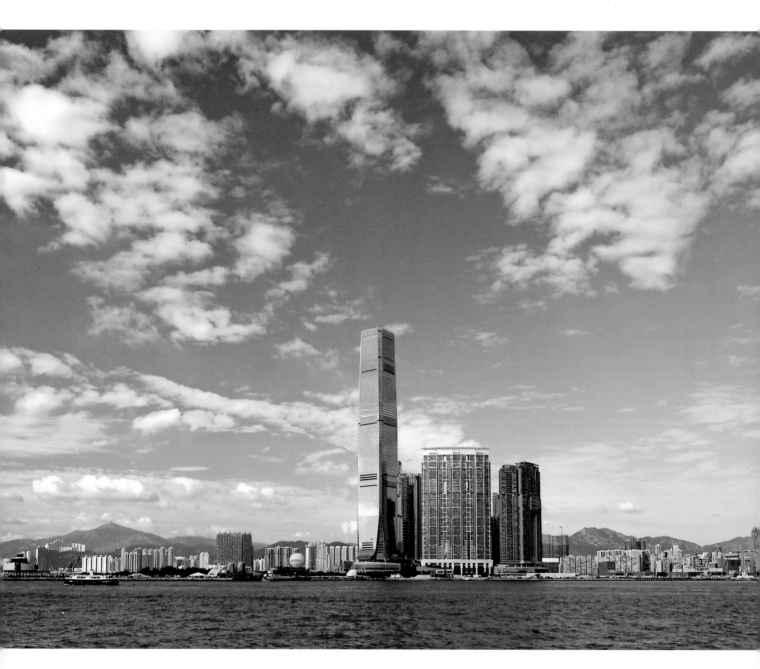

Hong Kong is also a region on China's sub-tropical southern coast, combining mainland and a host of islands, rich in biodiversity, with tranquil villages set amidst rugged hills, outstanding rock formations, a myriad hiking trails and around 40 per cent of the land area designated as country park – more, it is said, than any other territory.

Though the city with its iconic skyline is a vibrant destination in itself, it is Hong Kong's combination of contrasting urban and rural areas that really makes it a special, highly rewarding place to visit and to live in. Ringed by hills and fringing the South China Sea, the city has an outstanding natural setting.

Hong Kong is compact, too, offering opportunities to enjoy a wide mix of activities. You can hike through seemingly remote landscapes, explore South China villages, shop in designer stores and street markets and dine on gourmet cuisine – indeed, if you have the energy, you could even do so all in one day. But it is better, of course, to take a little time to blend destinations that appeal to you and discover the enchantments of Hong Kong.

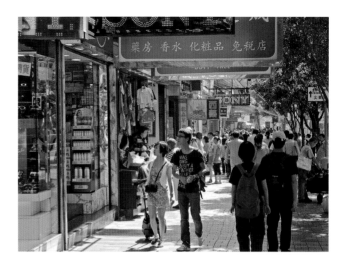

Above: Tsim Sha Tsui streets crammed with stores and festooned with neon signs make for stereotypical scenes.

Below: Exchange Square hosts the Stock Exchange in the heart of Central, Hong Kong's business district.

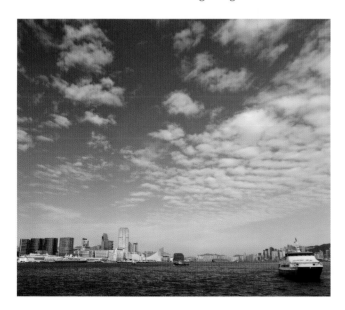

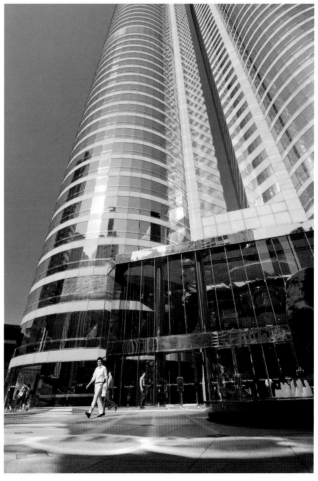

Opposite: ICC – Hong Kong's highest building – towers over Kowloon. Beyond lie hills in the New Territories.

Above: The western approach to Victoria Harbour, with Kowloon at left facing Hong Kong Island.

Geography and Climate

Dragons are prominent in Hong Kong culture, so it's appropriate that the main rocks were forged when dinosaurs – known in Chinese as 'fearsome dragons' – walked the earth. Magma was either blasted from volcanoes, creating volcanic rocks, or slowly cooled deep below ground to become granite. Once extinct, the volcanoes were eroded and weathered. Their interiors were laid bare, as hills were hewn from the volcanic rocks and granites. At the end of the last Ice Age, the sea flooded in across a coastal plain, transforming valleys into inlets and a myriad hilltops into islands.

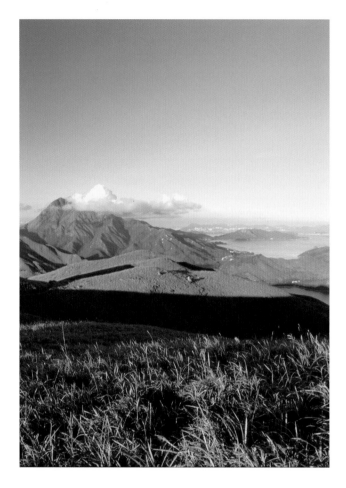

Hong Kong now has over 230 islands and islets. Lantau Island, in the mouth of the Pearl River, is largest at 147 km² (57 sq. miles). Hong Kong Island is next, with an area of 80.5 km² (31 sq. miles) – around seven per cent of Hong Kong's land area. It faces north to the Kowloon peninsula, beyond which lie the hills, valleys and plains of the mainland New Territories, and the border with China.

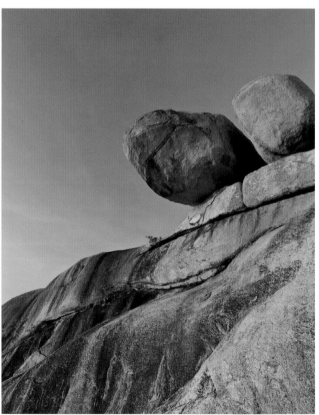

Above: *A scintillating summer afternoon view from southwest Lantau Island, with Hong Kong Island just visible to the east.*

Right: *Much of Hong Kong is hewn from granite, which on Cheung Chau has eroded to form precariously perched boulders.*

Urban Hong Kong is mainly concentrated on and around the north shore of Hong Kong Island and the Kowloon peninsula but also includes the new towns in the New Territories. High-rises abound and are home to the majority of the seven million residents. Elsewhere are rural lands with some farming, homes for commuters, abandoned villages and hillside plantations that help maintain water flows to reservoirs.

The climate is sub-tropical, marked by long, humid summers with consistently high temperatures, even at night; occasional monsoon downpours; and the need to be wary of heatstroke. Especially from May to October, tropical cyclones may sweep in from the sea, with direct hits by powerful typhoons (as hurricanes are known in the region) rare, yet potentially destructive. Autumns are typically dry, making this the best time to visit; springs can be damp. In winter, cold winds occasionally blast down from Siberia and though thermometers may read around 10°C (50°F), the wind chill factor can be freezing. Air pollutants abound, with view-shrouding smog wafting in when winds blow from the north, chiefly from September to May.

Above: A tallow tree adds splashes of autumn colour to mostly evergreen forest.

Below: Hills rising above tiny Green Island show Hong Kong Island has more to explore than the city of skyscrapers.

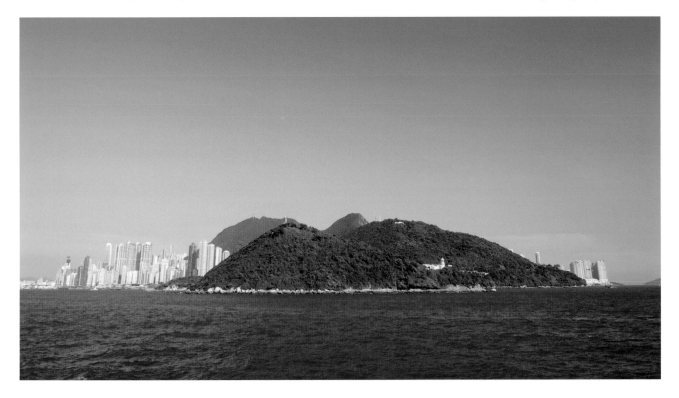

History

Archaeological evidence shows the area now known as Hong Kong was settled at least 35,000 years ago. It is known that around 6,000 years ago, Neolithic people lived by sheltered beaches and 4,500 years ago, Bronze Age people left relics including coastal rock carvings.

In around 214 BC, China's first emperor, Qin Shi Huangdi, sent armies to claim areas that included Hong Kong. For centuries, the land was not colonized, remaining home to peoples the Chinese referred to as 'barbarians'. Soldiers were stationed here, and traders arrived, though the main trade route passed by Hong Kong – with Arab merchants among those bound for Canton (Guangzhou). Tuen Mun, in northwest Hong Kong, became an important anchorage and garrison.

During the Song Dynasty (960–1279), Mongol forces ravaged swathes of China from the north. Members of the Tang clan were among the people who migrated south, with an official, Tang Fu Hsieh, settling in Hong Kong after retiring. His family became locally powerful, establishing villages and tilling fertile farmland. The Tangs were Cantonese-speakers belonging to the Punti – 'native-land people'. Wilder coastal regions remained the domain of fisherfolk, the Hoklo and Tanka, who at times turned to piracy and plundered trade ships.

As the Mongols swept south winning great battles on land and at sea, the last of the Song court fled, with two princes reaching the vicinity of Kowloon. The elder prince died, his brother was enthroned as the Emperor Bing of Song, at Mui Wo on Lantau Island, aged eight. His reign was brief; in 1279, with the Mongols' victory assured, he drowned in the sea, as the prime minister exhorted surviving members of the royal family to commit suicide.

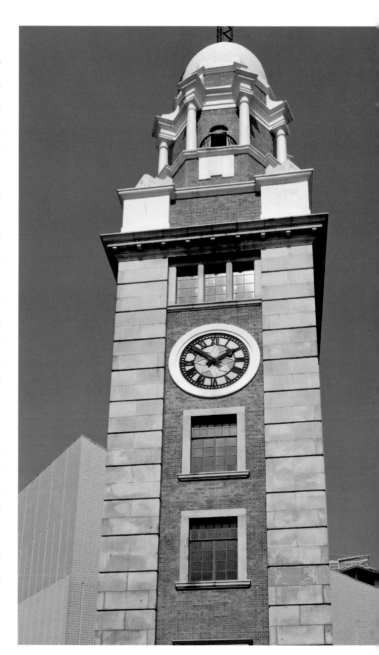

One of the most terrible periods in Hong Kong's history was also the result of dynastic turmoil, following the overthrow of the Ming Dynasty in 1644, which soon led to the establishment of the Qing Dynasty (1644–1911). Fearing remnant Ming forces on Taiwan, the early Qing Dynasty ordered a coastal evacuation in 1662. People were forced inland and houses destroyed without recompense. The draconian measure lasted seven years, and afterwards some abandoned villages became home to a new wave of immigrants: the Hakka, or 'guest people'.

Opposite: The Tsim Sha Tsui Clock Tower is all that remains of the original Kowloon Railway Station, which was demolished in 1978.

Below: Flagstaff House in Hong Kong Park is the oldest Western building in Hong Kong. Built in 1846, it served as the residence of the Commander of British Forces until 1978. Today, it houses the Museum of Tea Ware.

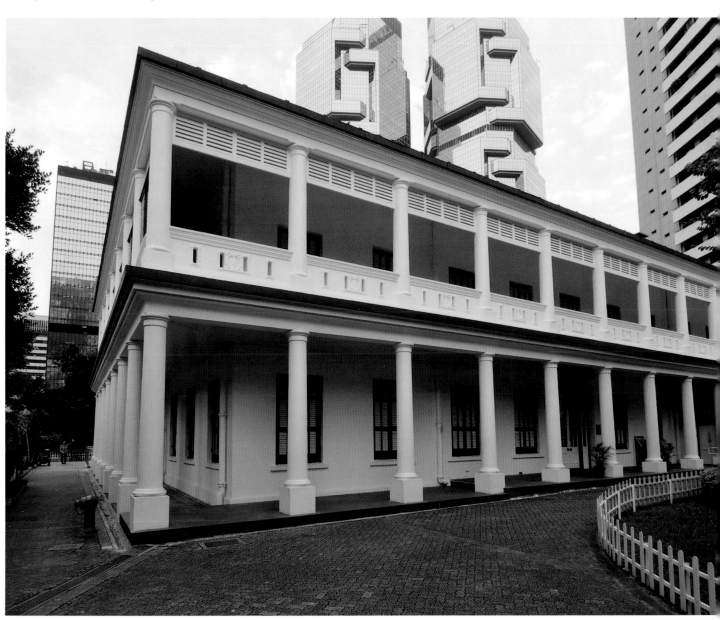

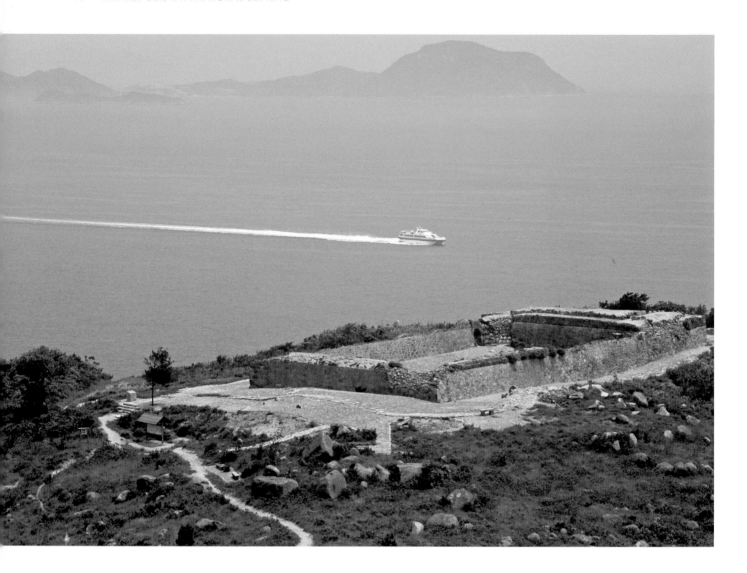

In the 18th century, Britain developed a thirst for tea from China and to help make payment, in turn nurtured a demand for opium. The trade generated huge profits and, early in the 19th century, resentment among Qing officials. China sought to stem the trade resulting in the first Opium War, when British forces attacked trade routes along the Pearl and Yangzi rivers. The war ended in 1842, with a treaty under which China ceded Hong Kong Island to Britain.

Britain had claimed the island a year earlier, though Foreign secretary, Lord Palmerston, complained it was "a barren island with hardly a house upon it", and predicted "Hong Kong will never be a mart of trade". The island's population was indeed only around 4,350 but naval officer Charles Elliot had chosen it for the excellent harbour, and even before the war was over, traders were establishing warehouses for opium and other goods.

In 1860, following more hostilities between Britain and China, the Kowloon peninsula was ceded to Britain. The colony was greatly expanded in 1898, with the addition of mainland and islands known as the New Territories – under a 99-year lease.

By the early 20th century, Hong Kong was a major shipping port, especially for entrepôt trade. Chinese revolutionaries, including Sun Yat-sen, made plans in Hong Kong, which culminated in the 1911 revolution on mainland China that ended 2000 years of imperial rule. Turmoil in the wake of the imperial government being overthrown led to more immigrants arriving in Hong Kong.

On 7 December 1941, Japanese forces attacked Pearl Harbor. Hong Kong was assaulted the following day and fell swiftly, with the surrender signed on Christmas Day. The occupation lasted till August 1945 and was brutal, reducing the population from 1,600,000 to under 600,000. Britain then resumed authority in Hong Kong. The Chinese flooded back, trade resumed.

In China, the Communists seized control on 1 October 1949. There was more turmoil and a huge surge in emigration to Hong Kong. In the 1960s and 1970s, Hong Kong became a manufacturing centre, creating textiles, toys, electronics and other goods for global markets. To alleviate severe housing problems, the government created high-rise estates and new towns in the New Territories.

The late 1970s saw mainland China begin opening up to the world. Cheaper food imports led to a sharp decline in Hong Kong farming, with many rural families heading to urban Hong Kong and the UK. Hong Kong manufacturers began establishing operations in nearby Guangdong. Hong Kong's economy became more service oriented.

On 1 July 1997, at the end of the 99-year lease, Hong Kong was handed over to Chinese rule, being designated as a Special Administrative Region under the principle of "one country, two systems" – with its own political system and judiciary. Hong Kong remains a major financial centre, albeit property tycoons are less venerated and political leaders have yet to fulfil the tantalizing post-colonial promise of 'Hong Kong people ruling Hong Kong'.

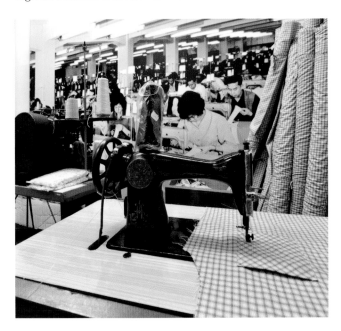

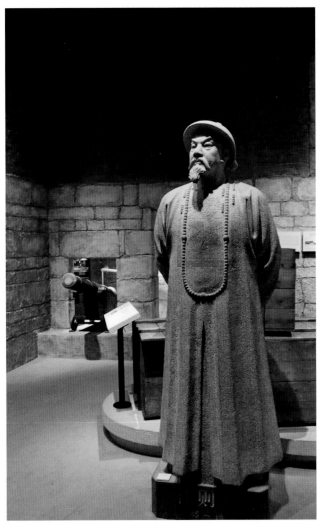

Opposite: Fan Lau Fort was built in 1729, on the southwest tip of Lantau Island. Overlooking the entrance to the Pearl River Mouth, it helped guard shipping routes to Canton (Guangzhou).

Above: A Museum of History exhibit portrays a textile factory from the 1960s.

Right: Also in the Museum of History: a statue of Commissioner Lin Zexu, a key figure in the first Opium War.

Religion, Festivals and Events

Though perhaps a million or more Hong Kong people – over one in seven – are adherents of organized religions, such as Buddhism, Christianity and Islam, Chinese folk religion infuses local culture and is integral to several of the main Hong Kong festivals.

Chinese folk religion encompasses Taoism, together with the worship of a host of spirits and gods that include stones and animals, and people both real and legendary who have become akin to saints. Walking in villages, you might see incense sticks burning at tiny shrines built of rocks where the Earth God resides; yet the modern metropolis has also been influenced by traditional beliefs. Some buildings are designed and oriented according to feng shui – Chinese geomancy – to maximize good fortune. The sharp edges of the Bank of China headquarters were even said to radiate ill luck towards buildings important to British rule.

Chinese New Year is the main Chinese festival and falls in late January or in February, according to the lunar and solar calendars. Its Chinese name means Spring Festival and this is chiefly a time for families to get together and prepare for the year ahead. Coupled with a three-day public holiday, this can make it a dull time for visitors without relatives here, though there is a big fireworks display on New Year's Eve and a New Year Night Parade.

The Dragon Boat Festival, also a national holiday, is livelier overall and may originate from a sacrifice to a fishing god. It's held in May or June, when days can be hot and steamy. Teams of paddlers race in long narrow canoes with dragon sculptures at the prows. Each boat also has a drummer to pound the rhythm for the strokes. Races are fast and furious and a series of knockout rounds culminate in the finals. The largest and perhaps most visitor-friendly dragon boat event is held at Stanley.

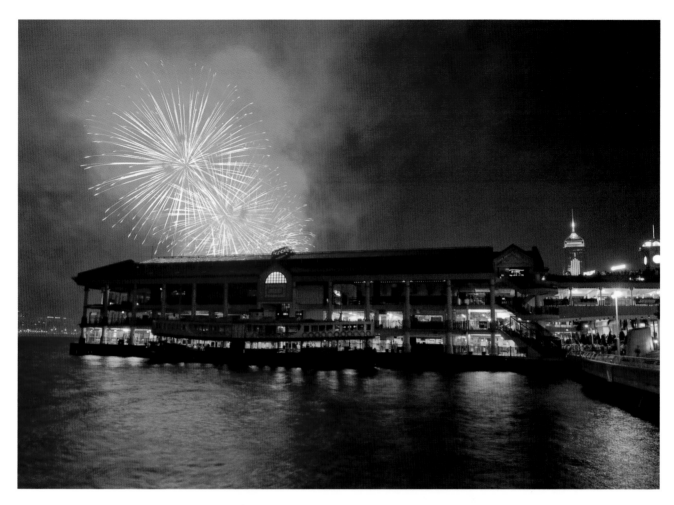

Above: Hong Kong holds celebratory fireworks displays in the harbour, notably on Chinese New Year's Eve.

Opposite: A sharp angle in the Bank of China headquarters supposedly radiated ill luck towards the Legislative Council Building.

Right: Cooling off after a frenetic heat in Dragon Boat races, on Cheung Chau.

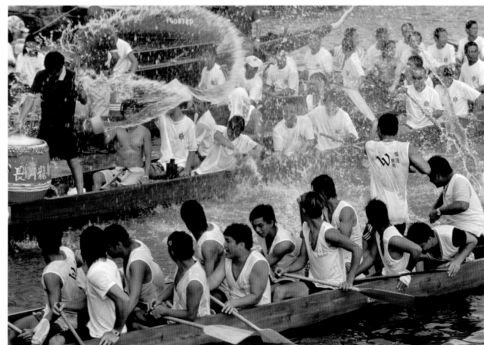

The Mid-Autumn Festival is another upbeat occasion. Also called the Moon Festival, it falls on the night of a full moon in September. People eat special food including mooncakes, and take children to parks, beaches and other vantage points to see the moon, light candles and play with glow sticks and colourful, nowadays mostly battery-powered, lanterns.

Ching Ming, in spring, and Chung Yeung, in autumn, are more solemn occasions, when people visit graves to worship and remember ancestors. Ghosts are never far away in Chinese religions and during August they are even released from hell for a while – giving rise to perhaps the quirkiest of the widespread annual festivals, Hungry Ghosts. On the evening of the Hungry Ghosts Festival, many people light incense sticks, burn paper offerings and put out simple food for ghosts, so they may leave earth sated.

Right: At Chinese New Year, worshippers throng Wong Tai Sin Temple in north Kowloon, lighting incense sticks and praying that their wishes come true. There's an intense melee on Chinese New Year's Eve, with people pushing to be among the first to offer incense after midnight. Even days later, the temple seems permanently shrouded in pungent smoke as latecomers salute the altars with incense sticks held aloft.

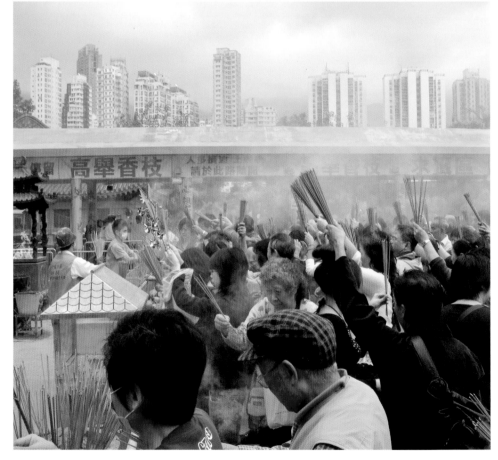

Left: During the Hungry Ghosts Festival, incense plus fake money and other paper offerings are burnt and foods like fruit are presented, to satisfy restless spirits and ensure they do not trouble the living.

Right: A splendidly costumed child waves to the crowd during the Cheung Chau Bun Festival parade. Later, at night, the festival has a serious side.

Below: Towards midnight on the climactic day of the Cheung Chau Bun Festival, a Taoist priest presides over the ceremony for sending ghosts back to the underworld.

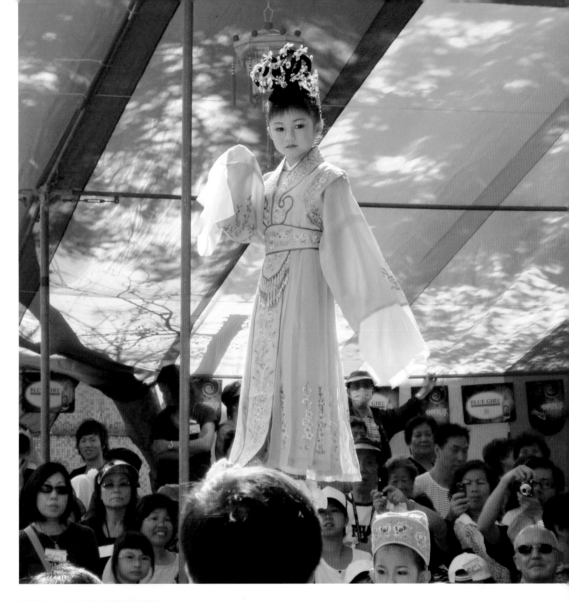

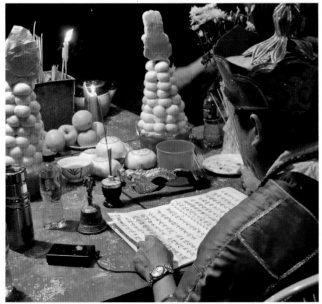

One island, Cheung Chau, even has an annual exorcism. The Bun Festival centres on buns set out for ghosts who have no-one to care for them, yet there is also a carnival atmosphere, including Chinese opera and a parade with lion dances, cacophonous music and cheerful floats.

The fascination with ghosts perhaps helps explain why Halloween is popular in Hong Kong. There are other western festivals, too. Easter is somewhat muted, but Hong Kong people enjoy Christmas, with no need for 'Happy Holidays' euphemisms.

The Rugby Sevens is an event that's chiefly for expats and visitors, who throng Hong Kong Stadium to party and sing, wear fancy dress, drink a cup of ale or two, and maybe even watch some rugby.

Cuisine

Eating out is immensely popular in Hong Kong, yet, for the most part, this does not mean contemplative, candlelit dinners for two – instead, locals favour heading to restaurants as families or in groups of friends. Meals can be lively, noisy affairs, even at breakfast time.

Dim sum is a characteristic style of local fare, eaten for breakfast, brunch or afternoon tea. Though Hong Kongers say they are going for *yum cha* – "drink tea" – it's the food that's the attraction. In typical dim sum restaurants, you choose a selection of dishes from a trolley piled with bamboo containers and plates holding pork dumplings, shrimp dumplings, egg tarts and chickens' feet, then eat the individual items in any order you wish.

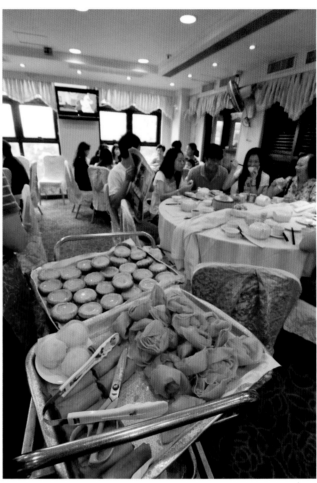

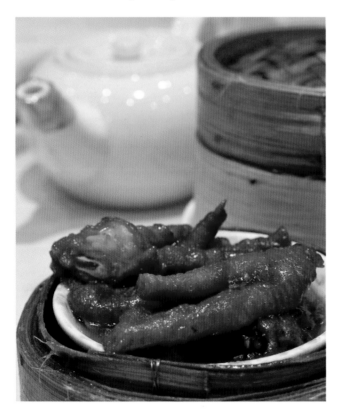

Hong Kong-style Western cuisine is also commonplace. It evolved in local cafés, known as *cha chaan teng*, with Western dishes amended to suit local tastes – such as steak with soy sauce, fried chicken wings, and French toast. Also reflecting the mixing of traditions is yuanyang: coffee and tea with condensed milk.

Left: Chicken feet are popular in dim sum restaurants, often stewed in sauce including ginger and black beans, and washed down with tea.

Above: Morning is a busy time for dim sum restaurants, especially as Hongkongers relax during weekends and holidays.

Nowadays, there is a feeling of nostalgia for the *cha chaan teng*, as well as for the roadside, open-air food stalls known as *dai pai dong* (restaurants with big licence plates). Hygiene concerns and modernization have led to many of the latter closing, though a few survive and Hong Kong still has a host of small eateries selling dishes like wonton (filled dumplings), noodles, fish ball noodles, congee (rice gruel) and vegetables in oyster sauce.

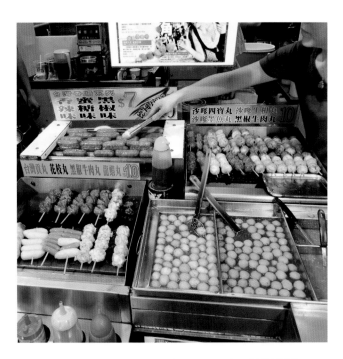

Below: Tourists and locals pack tables at popular eateries for al fresco dining in Temple Street, Kowloon.

Right: Popular street food includes fish balls, shrimp balls, satay and chicken wings, with some stalls becoming renowned for their fare.

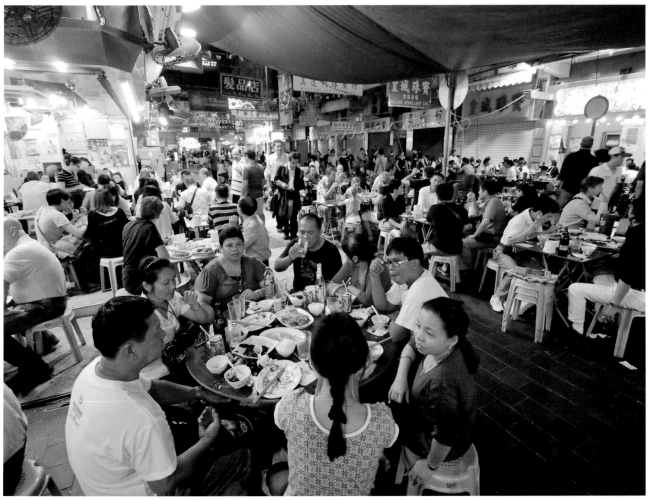

More upmarket establishments span an international gamut of cuisines. Cantonese food predominates. It's cooked with little seasoning and is perhaps tastiest in seafood restaurants, where you can feast on steamed fish, deep fried squid, scallops with garlic and prawns plus seasonal vegetables, perhaps with meat or poultry, such as chicken plus cashew nuts, sweet and sour pork, and pigeon with lemon sauce. Other Chinese regional cuisines include Beijing, Shanghai and Sichuan. These feature more seasoning and spices than Cantonese food. Note that Hongkongers mostly are not keen on chilli, so at least some Sichuan restaurants offer toned-down versions of spicy beancurd and other dishes that should be downright fiery.

In winter, several Chinese restaurants offer hotpots. Diners cook their own food in gently boiling soups – dropping in vegetables, meat, fish and beancurd, and eating them as and when they're ready. These hotpot meals are social affairs and especially favoured when chill north winds bring temperatures down to around 10°C (50°F): at outdoor restaurants, scenes of people in thick coats clustered around steaming hotpots are in great contrast to Hong Kong's typically tropical days and nights.

Japanese and Thai restaurants are popular, western fast food outlets and coffee shops are widespread and there are restaurants specializing in cuisines from all over the world. Restaurants with non-Chinese food tend to be in clusters, such as the eclectic mix of establishments from Lan Kwai Fong to Soho on Hong Kong Island, the lesser variety along Knutsford Terrace and the south Asian eateries within Chung King Mansions in Kowloon.

One notable place that's quintessentially Hong Kong is the lobby of Hong Kong's oldest hotel, the Peninsula, in Kowloon. Taking afternoon tea here ranks high among the list of things to do in Hong Kong; not so much for the finger sandwiches and delicate cakes served on elegant triple-tiered trays but for the echoes of a lost, grand colonial era.

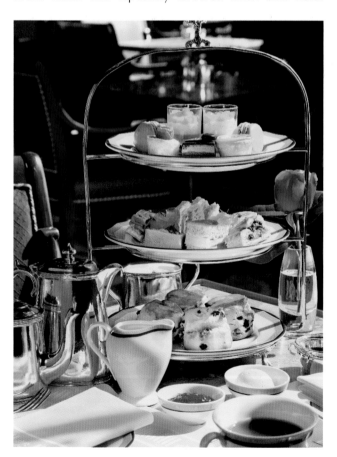

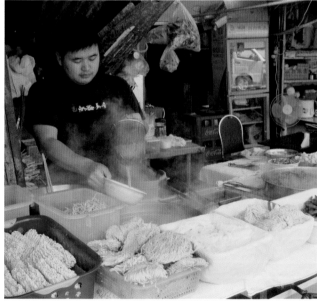

Left: *Afternoon tea in the Peninsula hotel lobby recalls bygone days and former guests such as Noel Coward, composer of "Mad Dogs and Englishmen".*

Above: *Steam rises from a 'dai pai dong' type stall serving Hong Kong style fast food, such as soup noodles, cooked to order.*

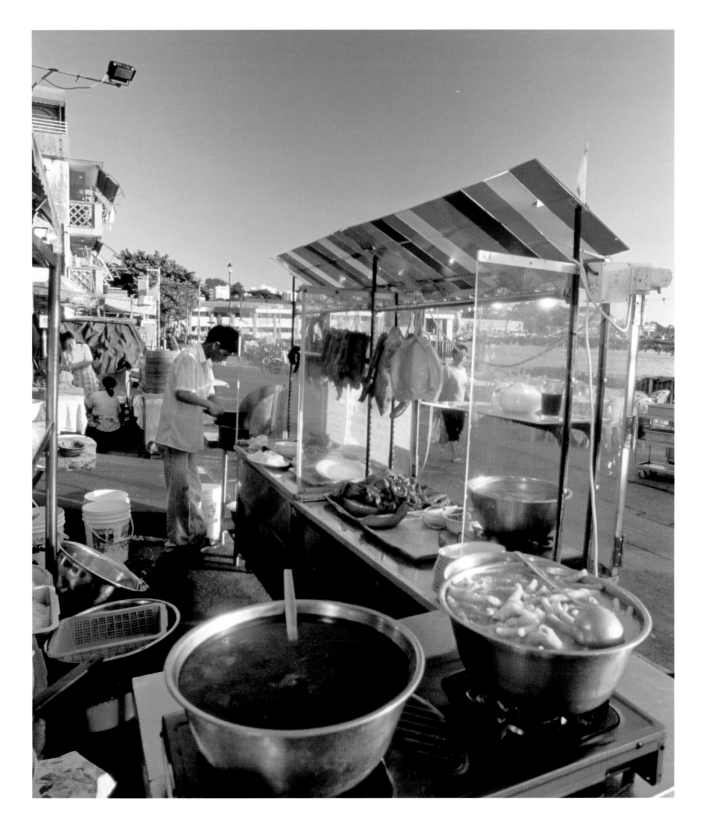

Above: With broths brewing, sausages and miscellaneous meat cuts displayed,

a cook on Cheung Chau prepares dishes to tempt passersby.

Shopping

Shopping is akin to a national pastime in Hong Kong. Stores and malls abound, and going to the mall during evenings and weekends is partly a way of spending time out of cramped apartments. With no sales tax or duty except on hard liquor and tobacco, Hong Kong has long been a magnet for international shoppers.

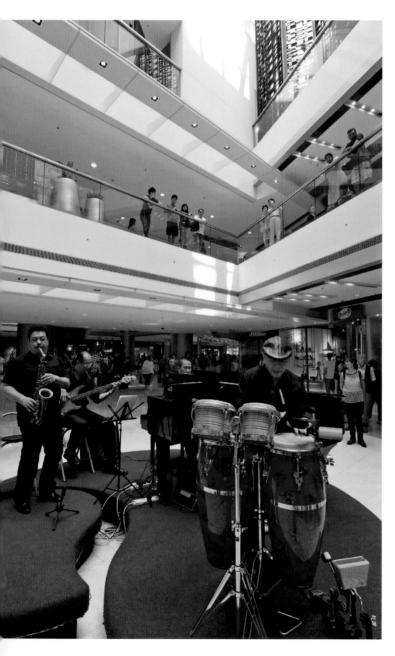

Globalization – including the internet – has perhaps led to some levelling of prices, which makes Hong Kong less distinctive than it used to be, yet there is still a wealth of Chinese arts and crafts. Hong Kong has also become akin to a grand shopping mall for visitors from mainland China, who surge through streets and stores seeking designer goods and electronics that are heavily taxed across the border, and even cosmetics and baby formula that they can buy without worrying whether or not they are fakes. The explosive growth in these visitors is transforming shopping in Hong Kong. International brands willing to pay outlandish rents are elbowing some local names out of several prime locations. Causeway Bay and Tsim Sha Tsui near and including Hong Kong's biggest mall, Ocean Terminal, are less focused on locals and overseas visitors, more aimed at mainlanders with money to spend, and spend fast.

Yet there are still places to shop in relative peace, including malls like Elements in Kowloon. Some streets leading off Nathan Road, Kowloon's "Golden Mile", remain good for browsing – though remember all Hong Kong is "tax free", and few stores with boldly lit brand names are actually named stores. Some fancy looking places can have over-enthusiastic sales staff, who may be a bit persistent and intimidating but, of course, if you are not comfortable with the approach, you can always walk away.

Left: Malls sometimes compete for customers by holding small exhibitions or, as here in Two IFC, by staging live music performances to entertain shoppers.

Several malls and streets are dedicated to certain types of goods, like Kowloon's Granville Road for factory outlet clothing and Star House for computer gear; Sai Yeung Choi Street, Mong Kok, for audio and video equipment; and Hollywood Road, Hong Kong Island, for antiques.

Above: The Landmark, in Central, is one of Hong Kong's best-established malls, and has retained a genteel air befitting its focus on expensive fashion, jewellery and lifestyle brands.

Right: Shelves crammed with souvenirs in Stanley Market – a perennial favourite with visitors to Hong Kong.

Theme Parks

Hong Kong has two main theme parks: the home-grown Ocean Park and the relatively new Hong Kong Disneyland.

Ocean Park occupies much of a hilly headland in southwest Hong Kong Island. It opened in 1977 and is managed by the Ocean Park Corporation, a not-for-profit organization whose aims include education and conservation alongside entertainment. As the name suggests, this popular park includes an oceanarium but it is also partly a zoo and an amusement park.

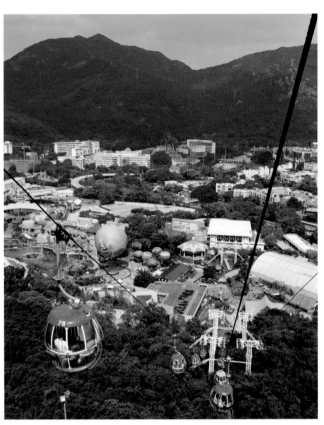

There are clusters of attractions near the main gate to the north of the headland and on the southern slopes. These are linked by a popular cable car, as well as a short railway that may better suit anyone without a head for heights. You can enjoy a range of activities, from admiring glowing jellyfish and spotting sharks and rays in the four-storey high aquarium, through photographing giant pandas and watching a dolphin show, to yelling and screaming on river rafts and roller coasters.

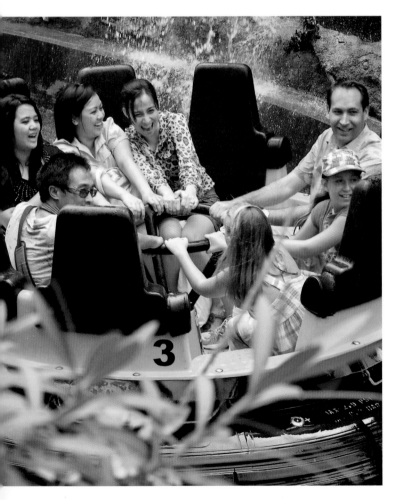

Left: Laughter along the Rapids at Ocean Park, where a cascade splashes boat riders as they swirl past.

Above: View from a cable car approaching the northern, Lowland section of Ocean Park, where a helium balloon is prominent near Aqua City Lagoon. The other terminal is at the Headland section, where attractions include roller-coasters.

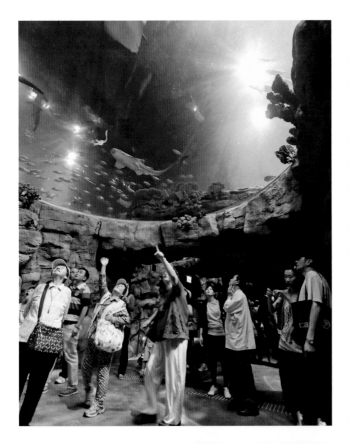

Hong Kong Disneyland is a newcomer that opened in 2005 on the east coast of Lantau Island. It is operated as a joint venture by the Walt Disney Company and the Hong Kong Government, and is the smallest of the world's five Disney theme parks. There's a strong emphasis on attracting visitors from mainland China, though it could soon lose the distinction of being China's only Disneyland, with a park scheduled to open in Shanghai in 2014.

Attractions are especially tailored to young children, with rides in Mad Hatter's teapots, a gentle boat trip passing scenes from around the world and the chance to zap Buzz Lightyear's foes. There are live shows, such as musicals, but it was only with expansion work that Hong Kong Disneyland began catering a little more for amusement park thrill seekers. For instance, Toy Story Land, which opened in 2111, includes a Parachute Drop and RC Racer – a U-shaped roller-coaster. Crowds gather to watch the parades of Disney characters along Main Street and especially for the nightly fireworks over Sleeping Beauty Castle.

Above: Spotting sharks, rays and other fish cruising overhead in Ocean Park's Grand Aquarium, viewed through the world's largest aquarium dome.

Right: Smiles and waves – and water spraying – from costumed participants in the parade along Main Street, a highlight of Hong Kong Disneyland's daily events.

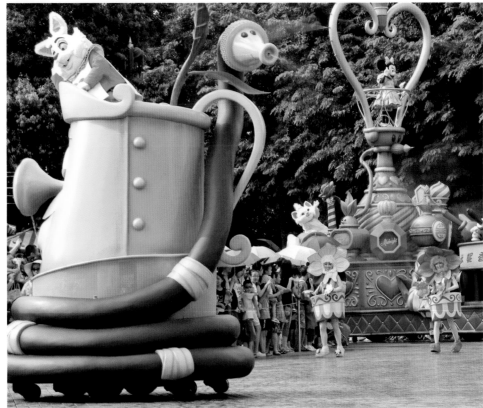

Protected Areas

Though Hong Kong is a relative newcomer to nature conservation, over 40 per cent of the land is in protected areas, chiefly country parks. Along the coasts, there are four marine parks and a marine reserve. These protected areas help safeguard landscapes and biodiversity, while also including facilities that enable locals and overseas visitors to escape the city.

Below: *Shorebirds and egrets in Mai Po Marshes Nature Reserve, northwest Hong Kong. Beyond lies Shenzhen, mainland China.*

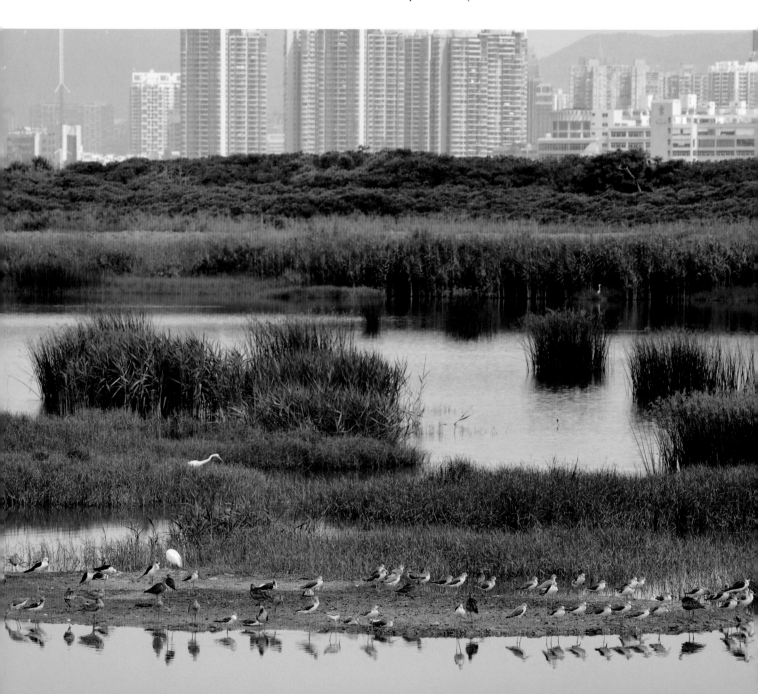

The country parks system originated in the late 1970s, when 21 country parks were designated within three years. Today, there are 24 country parks, covering much of Hong Kong's higher ground – with expansive deforested hillsides that are relatively poor for diversity but superb for scenery. They feature a wealth of trails, ranging from tree walks and family walks to long-distance paths, as well as barbecue sites and visitor centres.

A further 22 special areas have been created mainly for nature conservation. The best of these is Tai Po Kau Special Area, a forested valley in the central New Territories. Also in the New Territories are two notable wildlife sites that are not government managed: Fung Yuen Butterfly Reserve, and Kadoorie Farm and Botanic Garden.

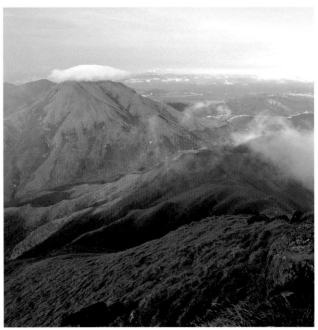

Sadly, some of Hong Kong's richest sites for biodiversity are woods and abandoned fields in village areas that were excluded from the country park system. Though their futures are uncertain, these are rewarding places to visit.

Marine life conservation is rudimentary. The marine parks and marine reserve afford some protection to creatures such as hard corals, shellfish and Chinese White Dolphins, yet face pressures including fishing.

With original forests long since cleared and fisheries depleted, Hong Kong's most significant wildlife area is Inner Deep Bay, in the northwest of the territory. This centres on an estuary shared by Hong Kong and Shenzhen, and in 1995 was listed as a Wetland of International Importance under the Ramsar Convention. Part of the wetland is protected in the renowned Mai Po Marshes Nature Reserve; there is also Hong Kong Wetland Park, with a gigantic visitor centre and a small wildlife habitat.

Left: The privately managed Kadoorie Farm and Botanic Garden aims to harmonize our relationship with the environment.

Above: Sunset Peak, at the heart of Lantau Island, is among the magnificent mountains protected by the extensive country parks system.

Plants and Animals

Stand on the edge of Victoria Harbour and look around, and you may soon conclude that Hong Kong is practically bereft of wildlife except for Black Kites – the large birds of prey that soar over and between buildings, and swoop to the water to grab fish. City parks are a little livelier, especially for birds.

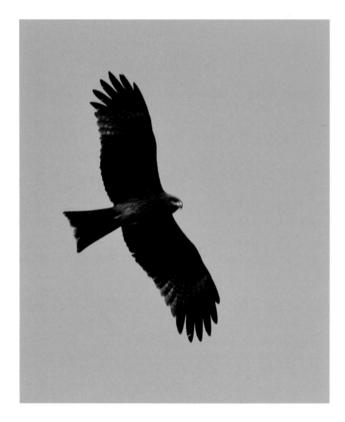

But it's as you get out of the city – even if just to the fringes, such as on the Peak, that you will find signs that Hong Kong is rich in biodiversity. Birds and butterflies are often in evidence, plus there are trees, shrubs and flowering plants – and echoes of the green jungles that were here long before the concrete canyons.

Though man has had a tremendous impact on Hong Kong's natural environment, there are still over 2,100 native kinds of vascular plants, including over 120 orchids and 300 tree species. These figures reflect the sub-tropical climate; compare this with temperate Britain which, though far larger, has just 35 native tree species. Hong Kong is also home to around 100 species of reptiles and amphibians,

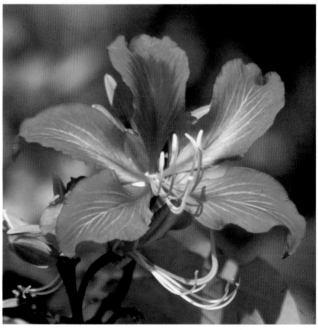

Above: Black Kites have been called 'Kings of Hong Kong' and are frequently seen over the city and harbour. Though some breed here, their numbers are highest in winter, when over a thousand gather to roost on Hong Kong Island.

Right: From mid-winter to spring, the beautiful flowers of Bauhinia trees enhance Hong Kong parks and gardens. Year round, its image graces the Hong Kong flag and coins. Known also as Hong Kong Orchid Tree, Bauhinia is a sterile hybrid relying on humans for propagation.

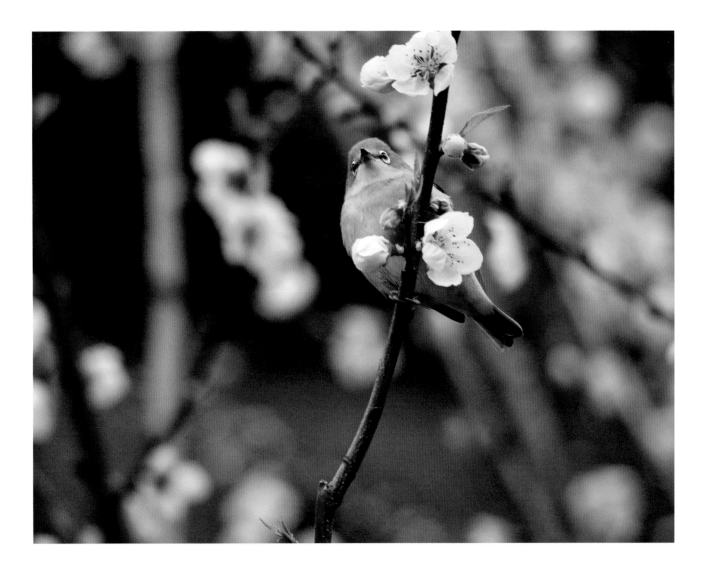

240 species of butterflies and 115 species of dragonflies. Some 500 bird species have been recorded and there are 84 species of hard coral – more than in the Caribbean.

This diversity results from the mix of habitats, as well as Hong Kong's position on the south China coast, at the north of the tropics. Thus there are plants and animals from more temperate regions together with others that are mainly tropical. Some are rare worldwide. The Hong Kong Paradise Fish, Romer's Tree Frog, two dragonfly species and a newly discovered firefly are among creatures found nowhere else on earth. Bauhinia, the Hong Kong Orchid Tree, was identified from a single specimen discovered on Hong Kong Island but is now widely propagated. Its flower is the Hong Kong emblem.

Birds are readily seen and heard. Common residents include Red-whiskered and Crested Bulbuls, which are fond of gathering in treetops and calling as if happily chattering to each other. Black-and-white Magpie Robins and Black-necked Starlings strut across open ground, parties of Japanese White-eyes forage in shrubs and trees. Spring and autumn also bring migrants passing through, en route to and from northern breeding grounds. Other northern birds arrive for the winter, notably the globally endangered Black-faced Spoonbill (see page 59).

Above: *A Japanese White-eye, one of the commonest Hong Kong resident birds, attracted by nectar in early spring blooms.*

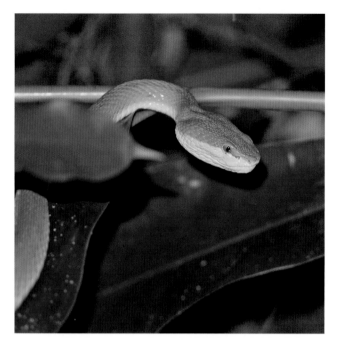

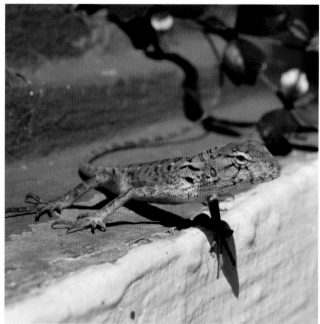

Above: Bamboo Snake is small but venomous. It's also known as White-lipped Pit Viper: a pair of heat sensitive pits in front of the eyes enable it to "see" heat in stereo. It can detect the warmth of a mouse 15 cm (six inches) away.

Above: Changeable Lizards can seem curious, sometimes remaining motionless and watching as people approach. They're also agile, ready to dash for cover when alarmed – or to chase and snatch insects.

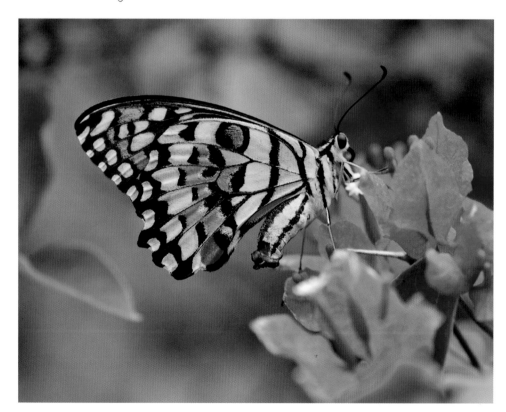

Left: Butterflies can be seen year-round in Hong Kong, though are scarce in cold spells. While some are tiny, many are large and eye-catching, including swallowtails, such as this Lime Butterfly.

Right: Lantern Bug is one of Hong Kong's quirkiest insects, feeding on the sap of longan and lychees, and with a mysterius "snout" that was once thought to emit light.

Reptiles and amphibians are most active in the hot, humid summer. Hong Kong's venomous snakes include Chinese and King Cobras but unless you walk wild trails in the dark, it's not easy to encounter a snake of any kind. On warm, wet nights, cries of amorous frogs resonate around rural areas. The oddest such sound is from the Painted Frog – like the moo of a bellicose cow.

Butterflies can be eye-catching, especially the larger swallowtails that may sport iridescent green patches or white flashes on their wings. Some arrive in autumn, such as the Common Tiger, which resembles the closely related, migratory monarch of North America. Red-bodied Skimmers are among the commonest dragonflies.

Mammals are mostly hard to find. There are introduced squirrels in some parks and macaques that mainly inhabit woods north of Kowloon. Wild boar are the largest land mammals; churned soil by woodland paths is a sign of their presence. As calls of small, shy muntjacs can be mistaken for dogs, they are also known as barking deer.

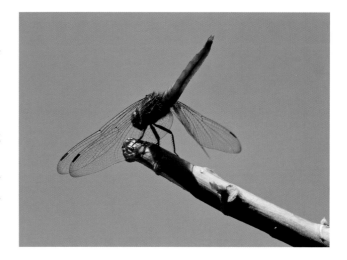

Above: Some 118 species of dragonflies and damselflies have been recorded in Hong Kong. Here, a male skimmer rests on a prominent perch, before patrolling the rest of his territory along a tiny stream.

Hong Kong has two resident marine mammals: the easily overlooked Finless Porpoise and the Chinese White Dolphin – which, when adult, is bubble-gum pink. Other marine life includes barnacles, crabs and anemones that can be found in rock pools. While small, strikingly patterned or oddly shaped fish might be glimpsed from some remote piers, you need to snorkel or dive to explore underwater realms, where coral patches with few fish are akin to city blocks where most people have vanished.

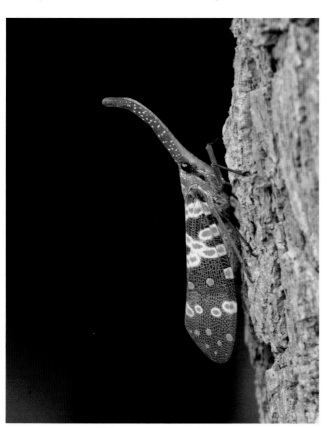

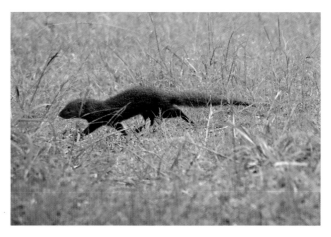

Above: A Javan Mongoose struts across open ground in Mai Po Marshes Nature Reserve.

Adventures

For an urban adventure in Hong Kong, head away from the tourist trails. Explore around the street markets of Mong Kok, say, and you will find "real" urban Hong Kong life, with people going about their daily lives in the world's most densely populated area. Narrow alleys between soaring old apartment blocks recall scenes from sci-fi movies; and Hong Kong indeed helped inspire one of the greatest science fiction movies, *Bladerunner*.

Outside the city, there is scope for a host of adventures. Hiking is excellent, though not to be taken too lightly: key advice for hot weather is to beware of dehydration, you may need to drink a litre (two pints) or more per hour. Other safety advice is more universal: a map is advisable, carry a phone if you can and let someone know where you are going. There are many gentle trails, often passing or ending at places where you can buy refreshments. If these are too easy for you, try more challenging routes, like sections of the 100-km (62-mile) Maclehose Trail that traverses the New Territories, and which a team of Gurkhas once completed in 13 hours 18 minutes.

There are designated campsites in several country parks and some far-flung beaches where people simply pitch tents above the high tide line, as at Tai Long Wan on the Sai Kung Peninsula. For a perhaps more comfortable overnight stay, try one of the few rural hostels.

Moving beyond hiking, some adventurers scramble up boulder-strewn stream valleys with successions of waterfalls; this is only advisable if you're fit and with someone who knows the route. Hong Kong has several rock climbing sites and hillsides where paragliders launch themselves into the air. Along coastlines are watersports centres, where you can hire windsurfers and sea kayaks. Snorkelling can be rewarding, though the water may be murky, and there are opportunities for diving.

For a gentler adventure, hire a boat, such as a small sampan, to view coastal scenery. Or, if you're with a group of friends, take a pleasure junk out for a day.

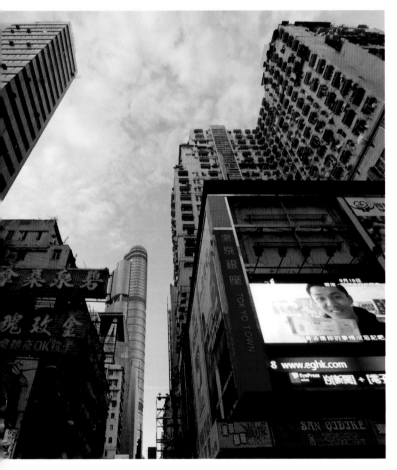

Left: Modern Langham Place looms amidst densely packed, older apartment buildings along Shanghai Street in Mong Kok, Kowloon. Explore here and nearby, and you'll discover scenes recalling – and inspiring – sci-fi movies, at the pulsing heart of urban Hong Kong.

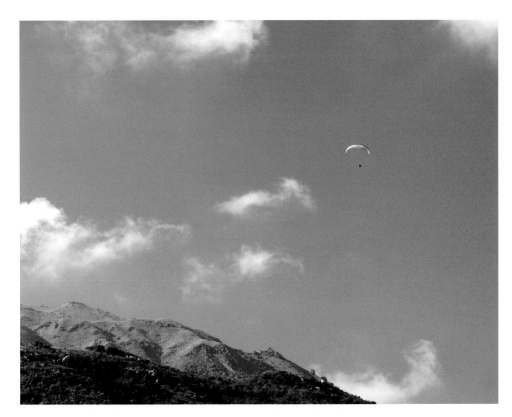

Left: A paraglider appears suspended in the air above Sunset Peak, on Lantau Island. A very different Hong Kong lies close to the city, with places ideal for hiking, a diverse blend of action sports, and for simply chilling out – as on Cheung Sha beach, from where this photo was taken.

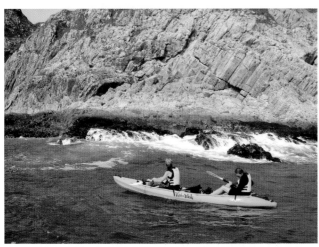

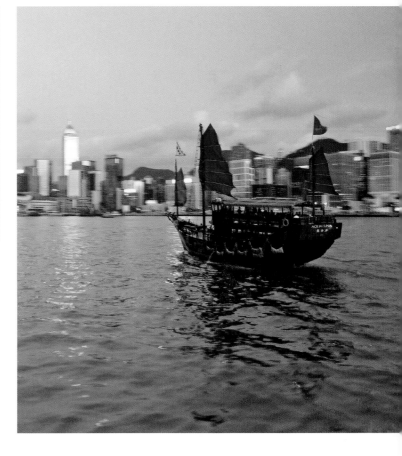

Above: Two intrepid sea kayakers pass Wang Chau, an island sculpted from columnar-jointed rock, in Hong Kong. Formed by volcanic explosions and pounding seas, this is one of the truly wild areas of Hong Kong.

Right: Pleasure junk outings make for a relaxing way to enjoy both wild and urban coastlines. The motorized Aqua Luna offers cruises, including one in Victoria Harbour.

Chapter 2: Hong Kong Island

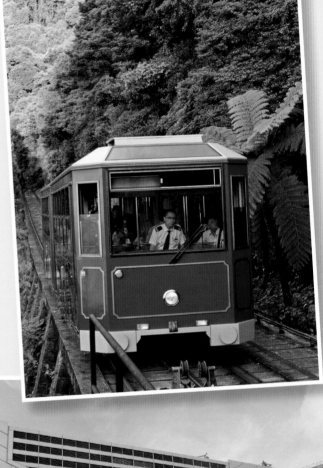

Hong Kong's name likely derives from *Heung Gong*, Fragrant Harbour, which was a village that exported incense made from Heung (or Incense) trees. After the colony was established, the harbour soon became a key element of archetypal views of water amidst hills, leading to Hong Kong being dubbed the "Pearl of the Orient".

The Peak

Some of the best vantage points for enjoying views over Hong Kong are on the upper slopes of 552-m (1,811-ft) Victoria Peak, which is the highest mountain on Hong Kong Island, often known simply as "the Peak".

Above: *A popular route to the top is by the Peak Tram, a funicular railway that climbs to 396 m (1,300 ft) above sea level.*

Right: *If the air is clear – especially in summer – there are grand views from the upper Peak Tram station.*

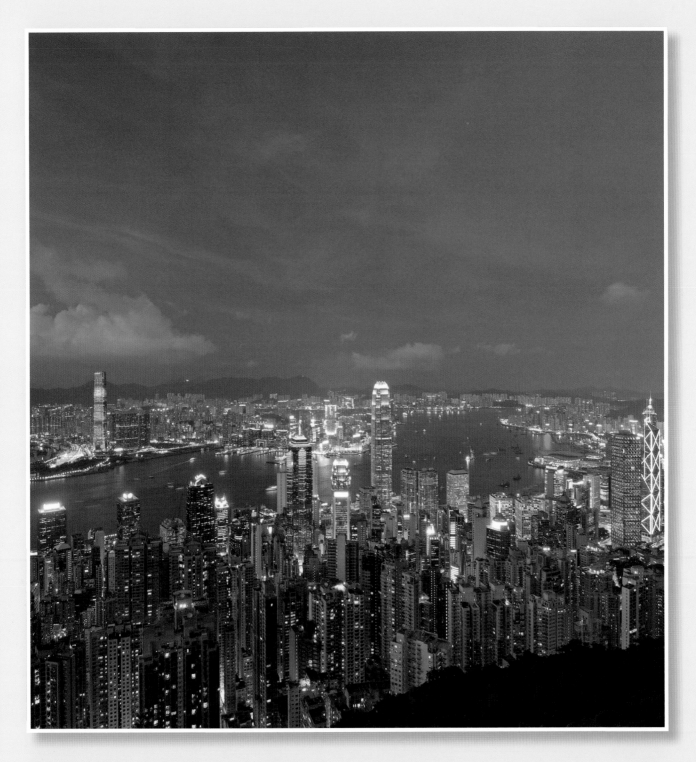

Above: Late afternoon can be a good time to visit the Peak; with building lights coming on as night approaches and making for colourful scenes even through soupy smogs. From here, you can appreciate how the tightly packed city hugs the north shore of Hong Kong Island – with many buildings on reclaimed land – and crams the Kowloon Peninsula. The green slopes of the Peak and the distant hills rising to the north of Kowloon help you appreciate Hong Kong's outstanding natural setting.

Central and Wanchai

Below: On the waterfront, Bauhinia Square is the place where, on 30 June 1997, Hong Kong was returned to Chinese rule.

Right: On the north shore of Hong Kong Island is Central, the business hub, with high-rises holding the Stock Exchange, bank headquarters and offices of multinational corporations.

Right: Most buildings look shiny and ultra modern but there are survivors from bygone eras, like the hundred-year-old former Supreme Court Building, renamed the Legislative Council Building.

Opposite: To the east lies Wanchai, which also boasts its share of office towers, yet is altogether more lived in.

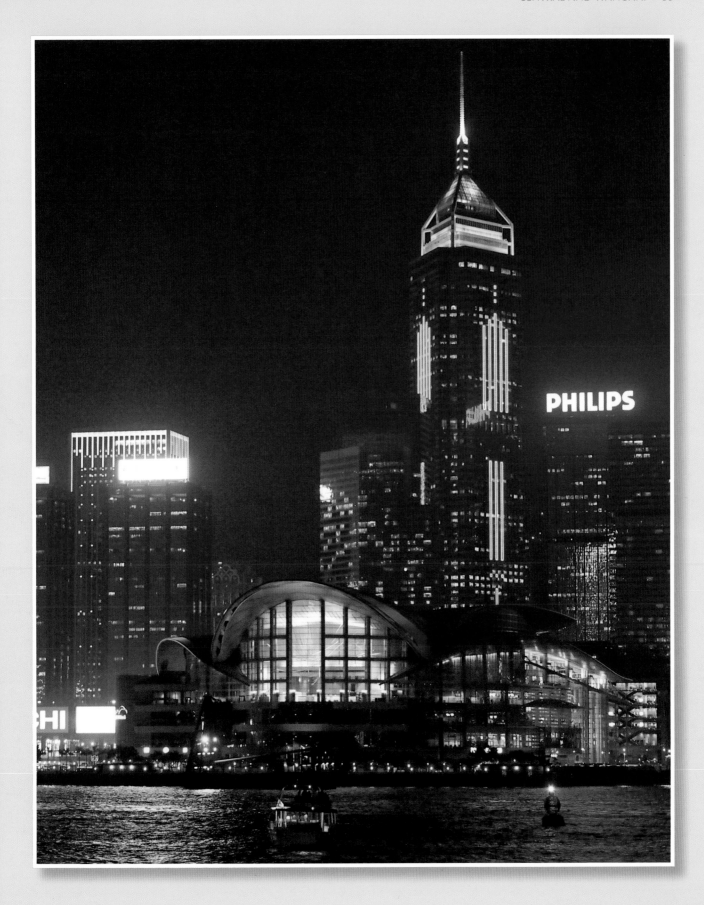

Government Hill and Parks

Right: The former French Mission Building in Central is near the foot of Government Hill, which has been a key site for Hong Kong administration since 1841 – and today offers a little sanctuary from the surrounding high-rises.

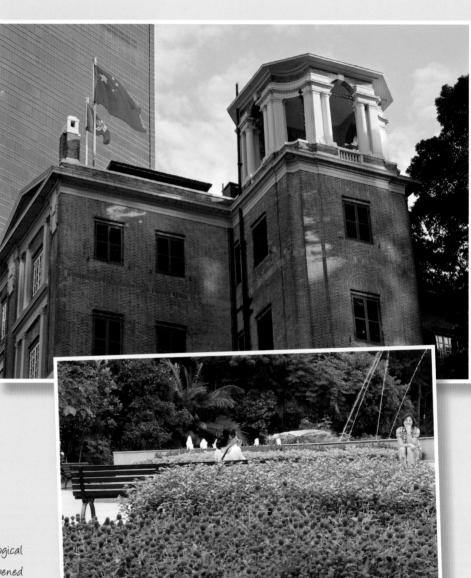

Right: Higher up the hill are the Zoological and Botanical Gardens, which first opened to the public in 1864 They are like a public park, with paths alongside cages and aviaries housing animals, including Orang-utans, and tropical birds. An open area with a fountain is a good place to rest and gaze over city buildings. East of the gardens lies Hong Kong Park, which features a walk-in aviary, along with an ornamental lake, observation tower and the Museum of Tea Ware in Flagstaff House.

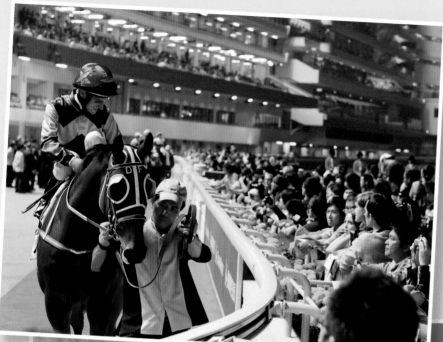

Left: Nestled at the foot of the island's hills, Happy Valley Racecourse is an immensely popular venue for horse races, which attract billions of Hong Kong dollars in bets over the course of a year.

Below: Near the foot of Government Hill, beside the former French Mission is the splendid St John's Cathedral, the oldest Anglican church in the Far East. A nearby site once housed government offices but with the relocation of these to a waterfront complex, its future is uncertain.

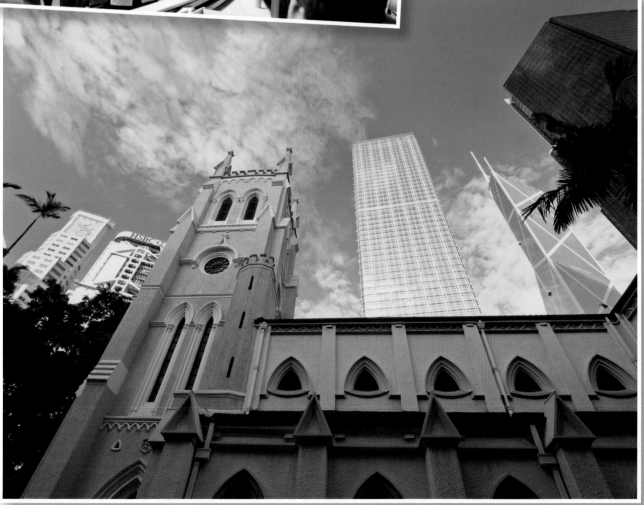

Wong Nai Chung and Tai Tam

At Wong Nai Chung Gap – a pass between the hills above Happy Valley – you can follow hiking routes, exploring the green interior of Hong Kong Island. Among the possibilities are a trail leading up and over the hills, then down to pass the four Tai Tam Reservoirs.

Below: Jardine's Lookout is a high point along the trails here, overlooking the north shore of Hong Kong Island, Victoria Harbour and Kowloon. Views from here (below and inset) show city changes, with ICC becoming a Kowloon landmark, and differences between summer air and misty looking autumnal smog.

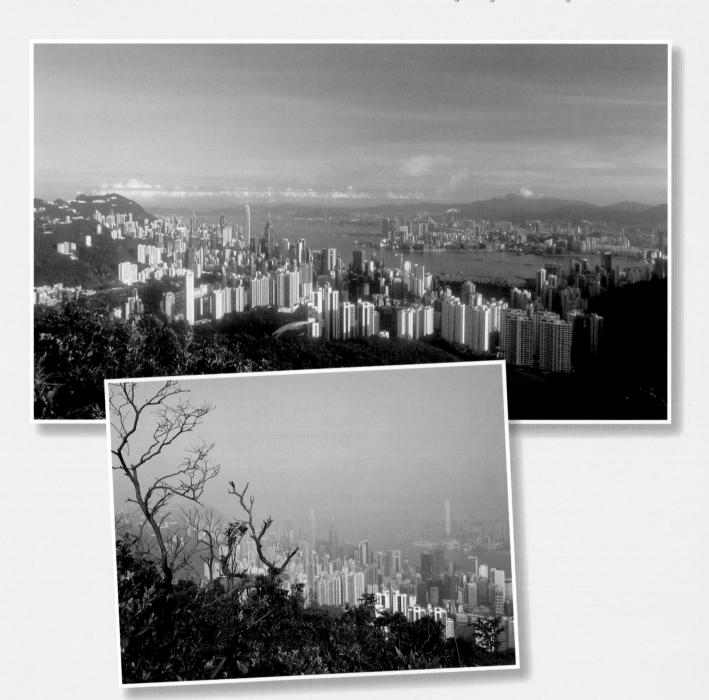

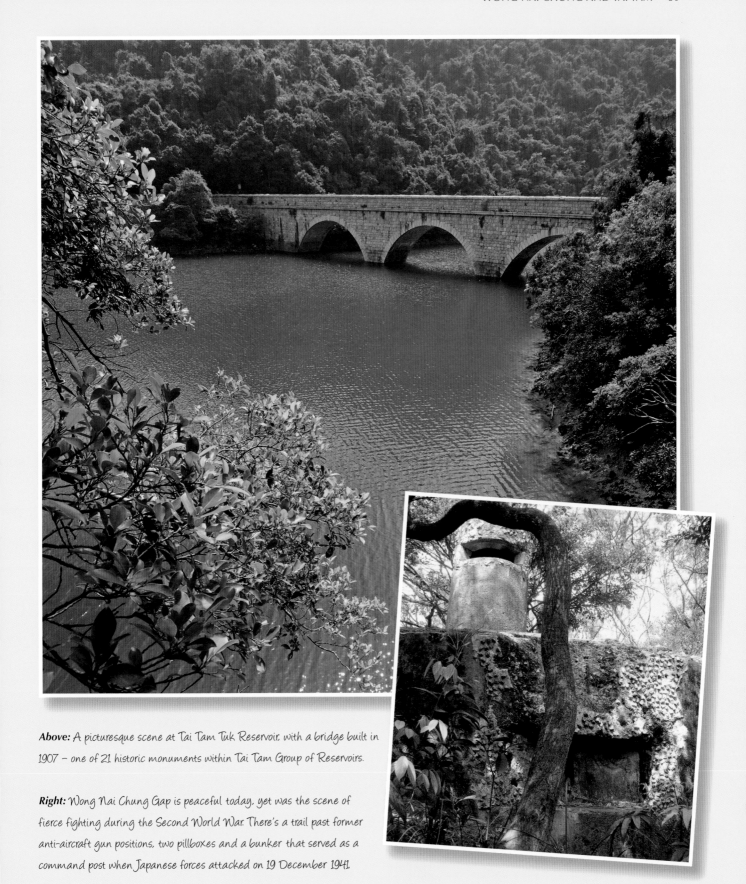

Above: A picturesque scene at Tai Tam Tuk Reservoir, with a bridge built in 1907 – one of 21 historic monuments within Tai Tam Group of Reservoirs.

Right: Wong Nai Chung Gap is peaceful today, yet was the scene of fierce fighting during the Second World War. There's a trail past former anti-aircraft gun positions, two pillboxes and a bunker that served as a command post when Japanese forces attacked on 19 December 1941.

Dragon's Back and Shek O

Though only a short distance from the city, eastern Hong Kong Island seems a world away. Perhaps the best short hike in the territory leads along the spine of a ridge known as Dragon's Back, below which is a quirky village on a wild stretch of coast.

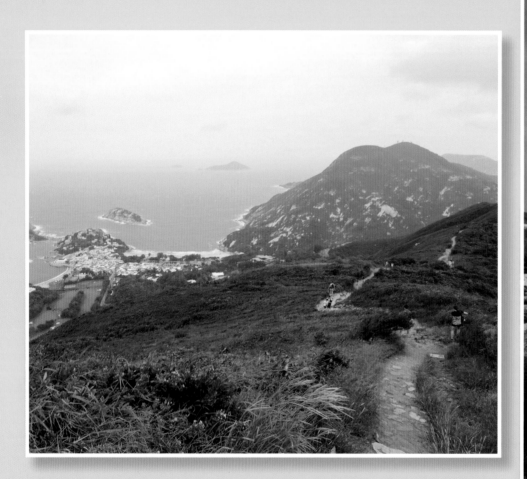

Above: Dragon's Back is on the 50-km (31-mile) Hong Kong Trail, that starts at the Peak and continues past the Tai Tam Reservoirs. The Dragon's Back hike passes through woodland on sheltered slopes and climbs to the ridge, where exposure to the elements has helped keep vegetation low, so views are expansive and impressive. Westward lie inlets and headlands on the south coast of Hong Kong Island and to the east is the South China Sea, with Big Wave Bay and the village of Shek O at the foot of the ridge. Big Wave Bay is popular with surfers, though the waves are rarely mighty, and can be a pleasant place to relax on the beach.

Opposite: Shek O has a good beach too, along with a quiet road you can stroll along. The road passes village houses, grand villas and small apartment blocks, leading to the tip of a headland and a nearby islet where, during easterly winds, waves roll in and pound the rocks and cliffs.

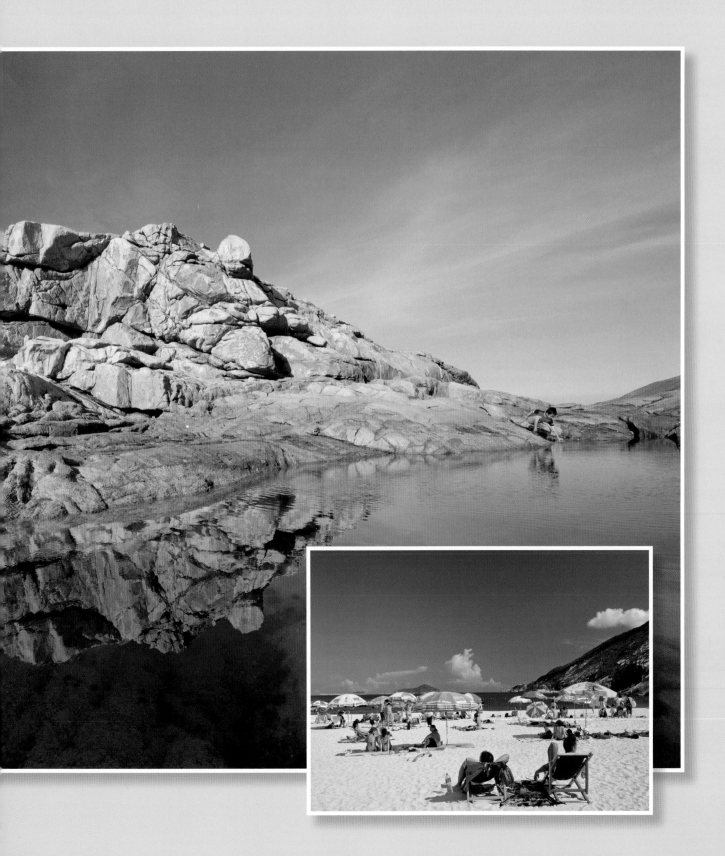

Stanley

Stanley is a small town on the south coast of Hong Kong Island. Best known for its market, it also has historic buildings and a couple of beaches and, when crowded, recalls a holiday resort with a far more relaxed air than pervades the city on the island's nearby north shore.

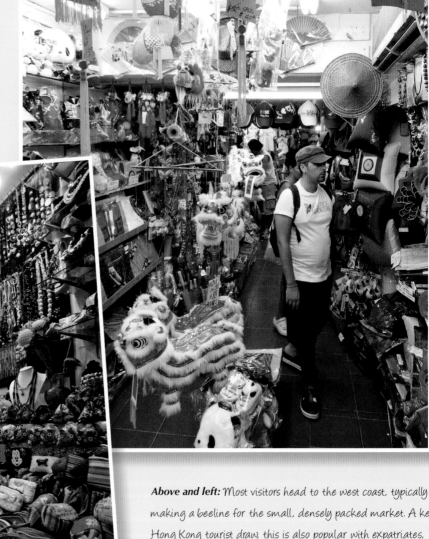

Above and left: Most visitors head to the west coast, typically making a beeline for the small, densely packed market. A key Hong Kong tourist draw, this is also popular with expatriates, partly as some shops have clothing in large sizes. There are souvenirs from China much as you find elsewhere in Hong Kong, along with toys, shoes and none-too-original paintings.

Left: Stanley occupies a narrow isthmus, with the Main Beach along the eastern shoreline, facing Dragon's Back; while to the west lie the market and a short seafront street with bars and restaurants of the kind found in many cosmopolitan places.

Left: A late summer afternoon at Stanley waterfront. On the right is the colonial-style Murray House – which was built near Central in 1846, dismantled in 1982, and rebuilt here in 2001

Nightlife

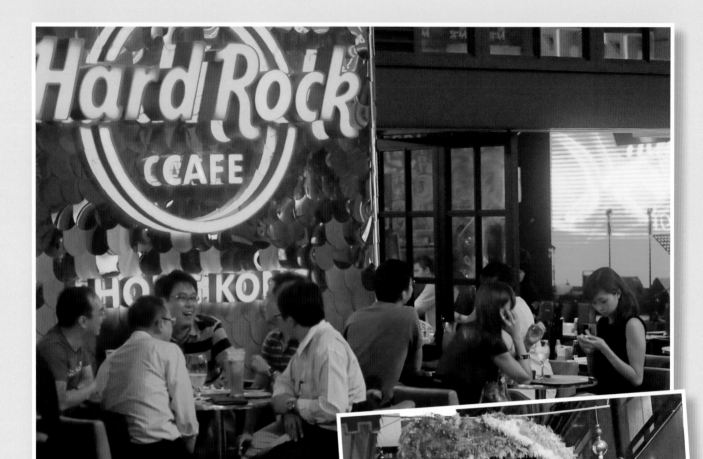

This page: Hong Kong's prime nightlife area is above the main business district, Central. This includes Lan Kwai Fong, a compact cluster of restaurants, bars and clubs that shot to fame in the 1980s. The short main thoroughfares close to vehicles on prime evenings, making it a location for drinking on the street, and a place for seeing and being seen. Further rebuilding in Lan Kwai Fong meant that nearby bars became quieter and a relatively new scene has burgeoned just above, along Wyndham Street.

Left: The area extends upwards beside the Mid-Levels Escalator to a district dubbed Soho – South of Hollywood Road. The emphasis here is on dining and you can choose from an eclectic mix of world cuisines. Melvis Kwok is a well-known local character, playing songs by his hero – Elvis Presley – for appreciation and tips.

Below: With a bawdy history, including as an R&R destination for servicemen during the Vietnam War, Wanchai is an earthier nightlife hotspot than Lan Kwai Fong. Longstanding girlie bars and discos mingle with newer pubs and restaurants.

Victoria Harbour

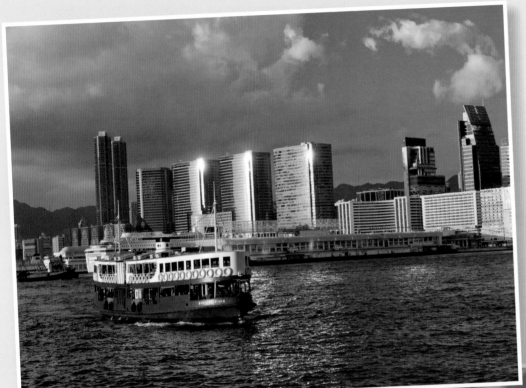

Left: The Star Ferry provides an excellent, cheap way of seeing Hong Kong's harbour, city and hills. From piers at Central and Wanchai, Hong Kong Island, there are frequent sailings to and from Tsim Sha Tsui, at the southern tip of Kowloon.

Below: ICC is prominent to the west of Tsim Sha Tsui pier, east of which is a fine waterfront promenade including the Avenue of Stars.

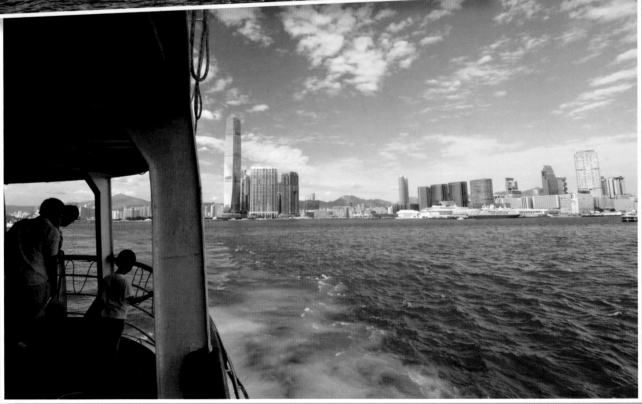

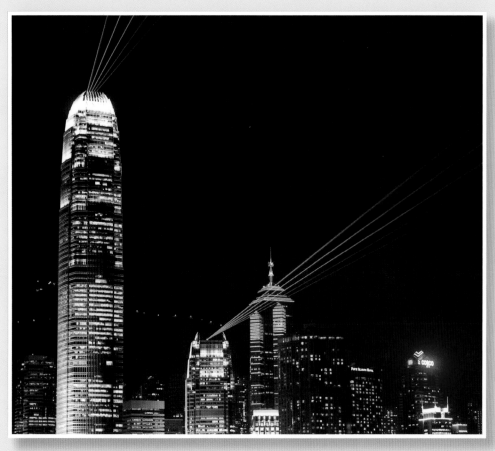

Left: From the Avenue of Stars you can enjoy the nightly Symphony of Lights, recognized by Guinness World Records as the world's "Largest Permanent Light and Sound Show".

Below: Dusk at the Central ferry piers, Hong Kong Island. In the background, Central Plaza stands head and shoulders above other high-rises near the Wanchai waterfront.

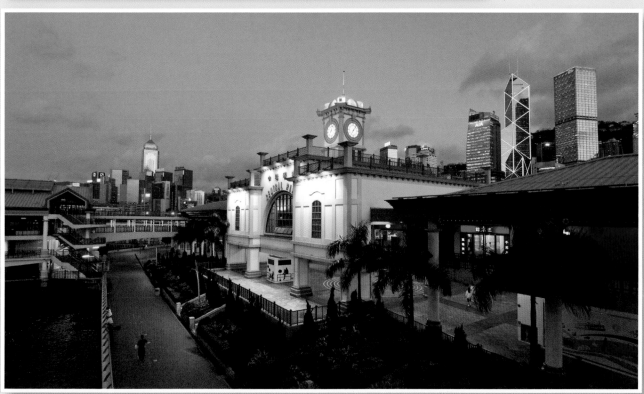

Chapter 3: Kowloon

Early last century, Kowloon was little developed – when governor Sir Matthew Nathan built a road north here, it was mocked as "Nathan's Folly". Yet today, Nathan Road is a major thoroughfare through bustling Tsim Sha Tsui and the most densely populated area on earth.

Tsim Sha Tsui

Recent redevelopment projects have transformed parts of Tsim Sha Tsui. Some places are far less pedestrian friendly, funnelling shoppers and sightseers through a tunnel system. 1881 Heritage is the result of a private redevelopment of the historic Marine Police Headquarters, where relics include typhoon signals, but the emphasis is on upmarket shopping. One place that has largely resisted change is Chungking Mansions, a 17-storey building dating from 1961. This is like a world unto itself, with a warren of cheap guesthouses and restaurants, and a host of small businesses.

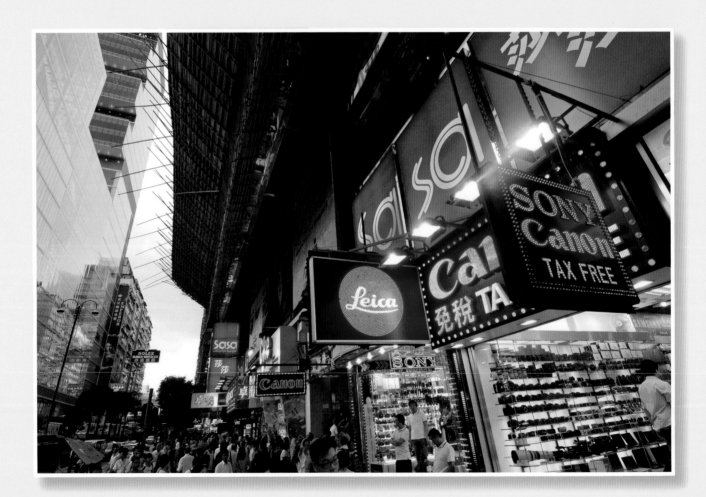

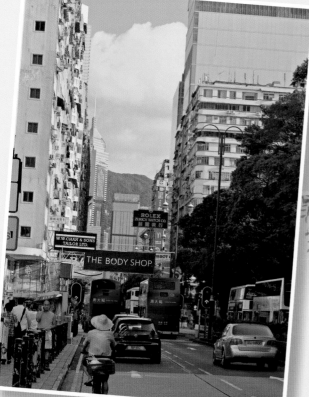

Below: *Across Nathan Road from the mansions, Kowloon Park is like an oasis in the city, offering respite from the bustling streets. As well as fountains, it includes playgrounds, a sculpture garden, an aviary and an ornamental bird lake.*

Above and opposite: *Along Nathan Road and nearby streets in Tsim Sha Tsui are the classic sights and sounds of tourist Hong Kong: shops abounding with cameras and clothes, silks and cloisonné; multitudes of overhanging neon signs; bustling crowds; touts offering custom tailoring or muttering "copy watch". Here, you can rub shoulders with shoppers searching for bargains and curios.*

Museums

Below: The Hong Kong Museum of History is in a complex together with the Hong Kong Science Museum which, with a multitude of hands-on exhibits, is geared towards children, though can be fun for adults too.

Opposite: The history museum is perhaps the most interesting of the Kowloon museums, particularly for its large permanent exhibition, The Hong Kong Story, which illustrates daily life from prehistoric times through to Hong Kong's handover to China in 1997.

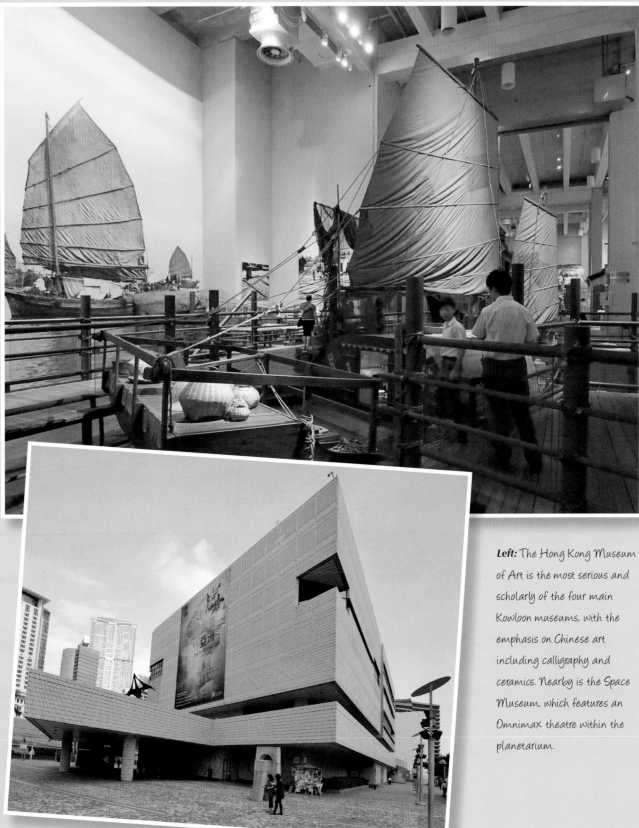

Left: The Hong Kong Museum of Art is the most serious and scholarly of the four main Kowloon museums, with the emphasis on Chinese art including calligraphy and ceramics. Nearby is the Space Museum, which features an Omnimax theatre within the planetarium.

North of Tsim Sha Tsui

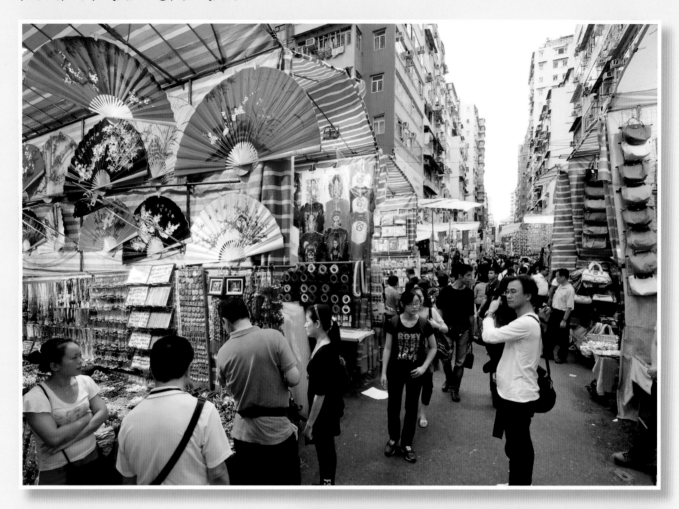

This page: Ladies' Market – along Tung Choi Street – has become popular with tourists. In the afternoons and evenings, people stroll past stalls crammed with cheap clothes and bags, paintings and trinkets. You can try bargaining hard here but don't expect too much in the way of quality.

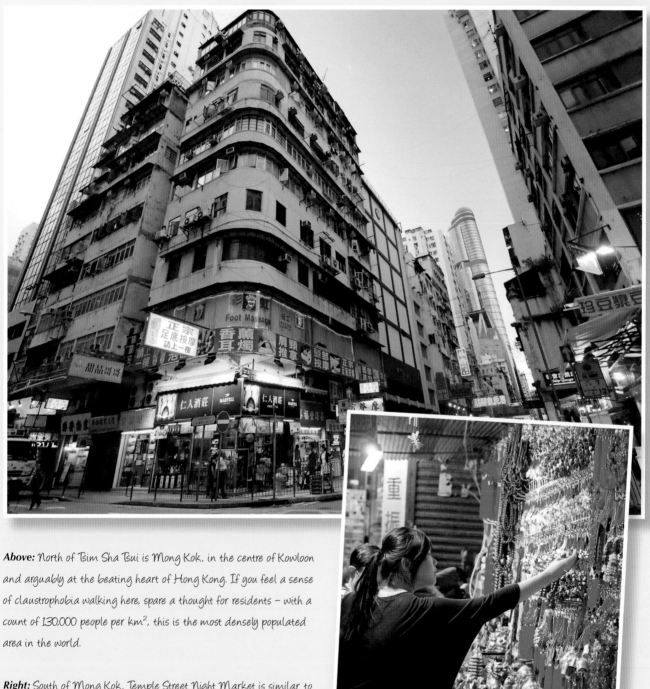

Above: North of Tsim Sha Tsui is Mong Kok, in the centre of Kowloon and arguably at the beating heart of Hong Kong. If you feel a sense of claustrophobia walking here, spare a thought for residents – with a count of 130,000 people per km², this is the most densely populated area in the world.

Right: South of Mong Kok, Temple Street Night Market is similar to Ladies' Market, though as the name suggests, it mainly comes alive in the evenings, and there are rather more clothes for men. Fortune tellers are among the attractions. Bustling open-air restaurants are good places to sit and watch city life.

Wong Tai Sin and Chi Lun Nunnery

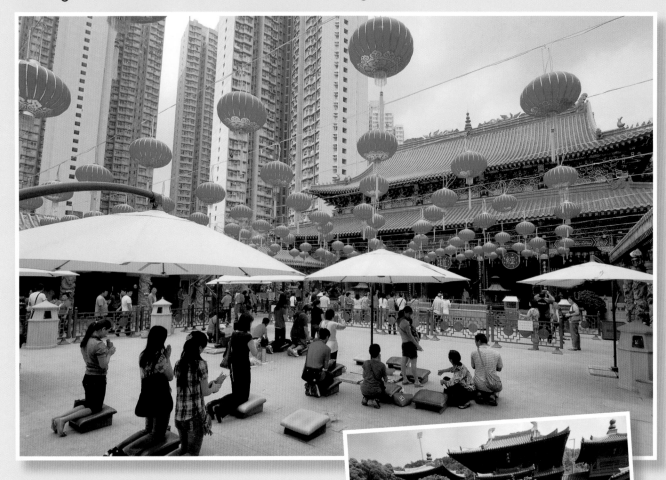

Above: In north Kowloon, Wong Tai Sin is Hong Kong's only district without a coastline. It's named after the large and busy Wong Tai Sin Temple, which is dedicated to a Taoist god – Wong Tai Sin, the Great Immortal Wong. Buildings include the main hall, together with a Nine Dragon Wall modelled on the wall of the same name in Beijing's Forbidden City, and a Chinese style garden. Wong Tai Sin Temple is especially crowded at Chinese New Year, when people pray for their wishes to come true. It is also popular for fortune telling, with many people using fortune sticks, and fortune-tellers advising visitors including tourists.

Right: East of the temple lies the Chi Lin Nunnery complex, which was founded in 1934 and rebuilt in the 1990s. The buildings are in the Tang Dynasty (618–907) style of architecture, with wooden frames joined together without nails.

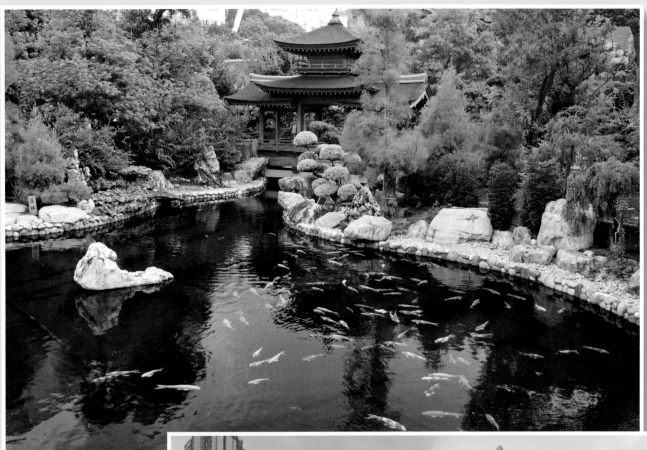

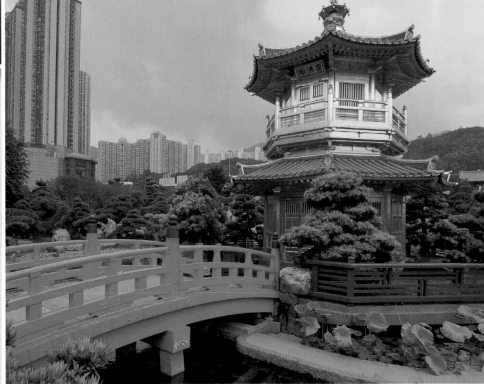

This page: Adjoining the nunnery, the Nan Lian Garden is modelled on Tang Dynasty style landscaped gardens.

Chapter 4: The New Territories

The New Territories strictly refers to land leased to Britain for 99 years from 1898, including the north of present-day Kowloon and over 200 islands. Today, however, the term often refers only to mainland Hong Kong north of Kowloon. There are urban areas – the "new towns" – together with farmland, forests, wild hills and coastlines.

Hong Kong's highest mountain, 957-m (3,140-ft) Tai Mo Shan, reigns over the central New Territories. Its name means Big Hat Mountain, as from some angles it resembles a broad conical hat, but it's also known as Big Misty Mountain after the clouds that often shroud the summit. Because humid air rises and cools over Tai Mo Shan, this is among the wettest places in Hong Kong, averaging 240 cm (94 inches) of rainfall per year, which in turn nurtures lush vegetation. Hong Kong's best forests for biodiversity are here, particularly in the Tai Po Kau Nature Reserve.

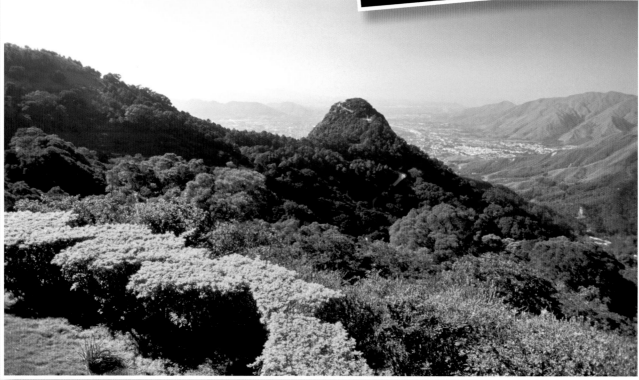

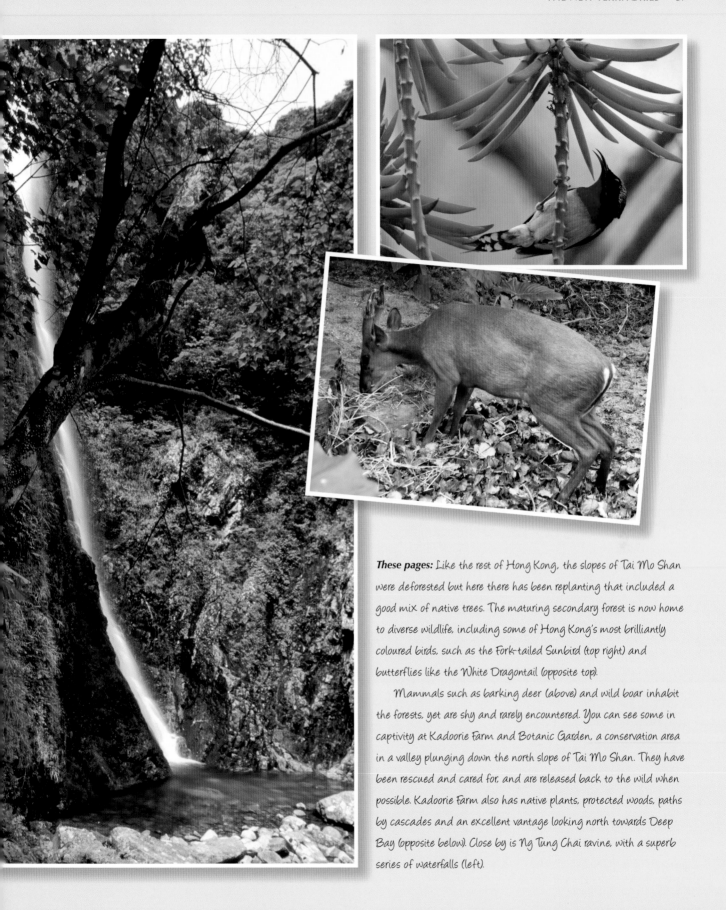

These pages: Like the rest of Hong Kong, the slopes of Tai Mo Shan were deforested but here there has been replanting that included a good mix of native trees. The maturing secondary forest is now home to diverse wildlife, including some of Hong Kong's most brilliantly coloured birds, such as the Fork-tailed Sunbird (top right) and butterflies like the White Dragontail (opposite top).

Mammals such as barking deer (above) and wild boar inhabit the forests, yet are shy and rarely encountered. You can see some in captivity at Kadoorie Farm and Botanic Garden, a conservation area in a valley plunging down the north slope of Tai Mo Shan. They have been rescued and cared for, and are released back to the wild when possible. Kadoorie Farm also has native plants, protected woods, paths by cascades and an excellent vantage looking north towards Deep Bay (opposite below). Close by is Ng Tung Chai ravine, with a superb series of waterfalls (left).

Mai Po and Long Valley

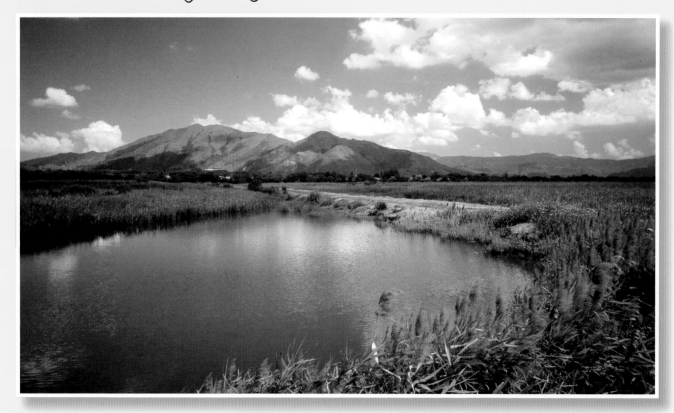

This page: At Deep Bay, on the northwest border of Hong Kong, there is an internationally important wetland complex, centred on a shallow estuary. Tidal mudflats, mangroves, fish ponds and shrimp ponds attract wildlife including tens of thousands of migratory waterbirds each year. Egrets and herons are readily seen year-round (right), but are especially common in winter, when other waterbirds seeking refuge from North-East Asia include cormorants, ducks, shorebirds and gulls. There are intense urban developments, especially along the north shore in Shenzhen, mainland China, but also some protected areas – particularly the Mai Po Marshes Nature Reserve (above).

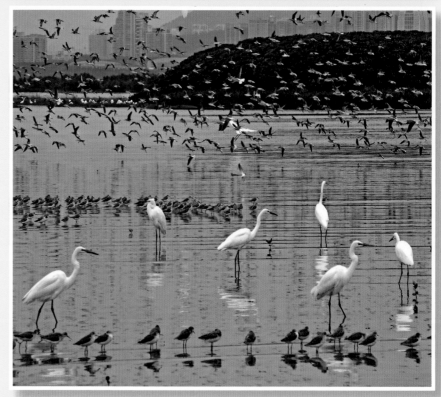

Below and right: Winter is the prime season for seeing a Mai Po star bird – the Black-faced Spoonbill (below), that has a world population of only around 2,500. Other global rarities pass through on migration, notably shorebirds, such as the diminutive, almost extinct Spoon-billed Sandpiper. Black-winged Stilt is a resident, readily seen at Mai Po and Long Valley (right).

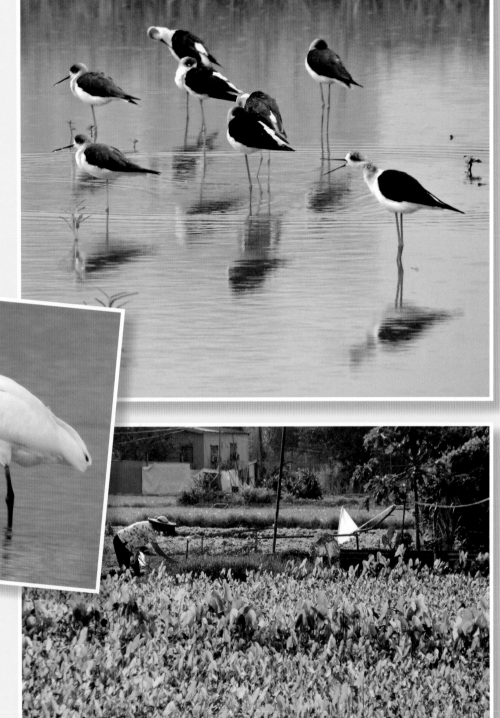

Right: East of Deep Bay, an area of wet fields has been afforded some protection at Long Valley. Traditional vegetable farming plus the return of small rice paddies to Hong Kong, make this a hotspot for a wide variety of birds and an interesting place for catching glimpses of south China rural life.

Ping Shan and Lung Yeuk Tau Heritage Trails

These pages: Around the 10th century, members of the Tang clan arrived in Hong Kong, quickly becoming prominent and powerful, and establishing villages in areas including the north of the present-day New Territories.

There are heritage trails through two important Tang village areas. They pass buildings including Hong Kong's only ancient pagoda. The Tsui Sing Lau Pagoda (Pagoda of Gathering Stars) is at the start of the Ping Shan Heritage Trail. It's a three-storey brick building (right), attractive in itself yet in an ugly, mostly concrete setting. Further along the trail surroundings are more rural. Highlights are surely the Tang Ancestral Hall (far right above and below), a splendid building that's perhaps 700 years old; its neighbouring near-twin, the Yu Kiu Ancestral Hall, built in the 16th century; and Kun Ting Study Hall (below centre). In these, villagers worshipped their ancestors and held activities ranging from classes for children to festival banquets.

The Lung Yeuk Tau Heritage Trail is through a greener area, though the buildings are not quite so grand. Here, too, there's a fine ancestor hall, with a handsome temple beside it. There are also walled villages (below), built to defend residents against attacks by bandits and during feuds with other clans.

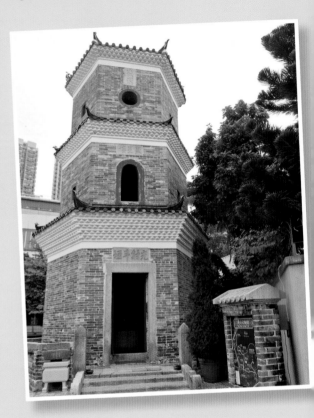

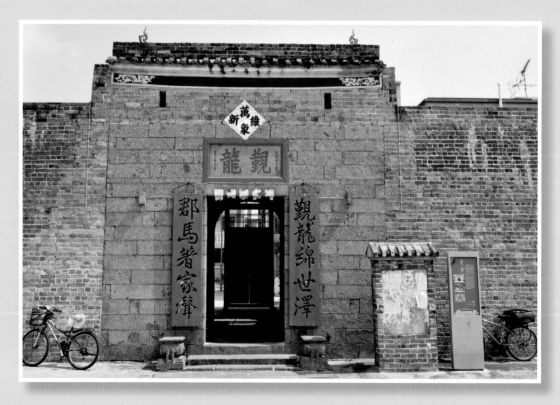

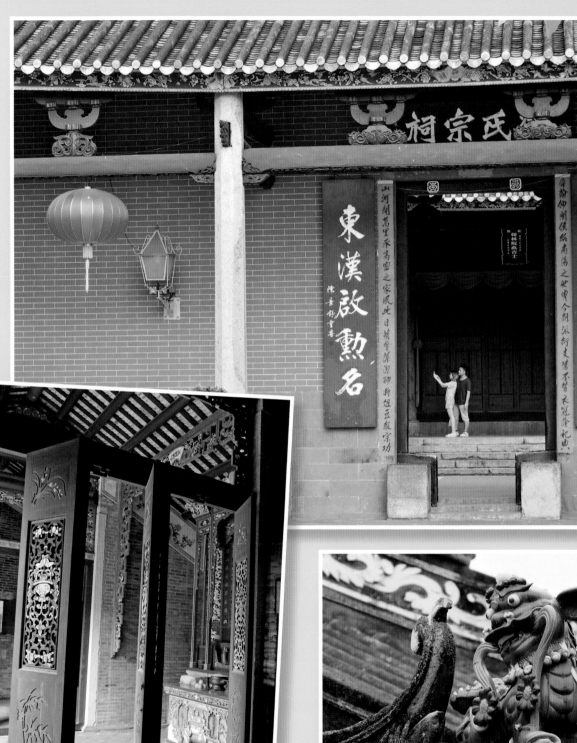

Sai Kung Peninsula

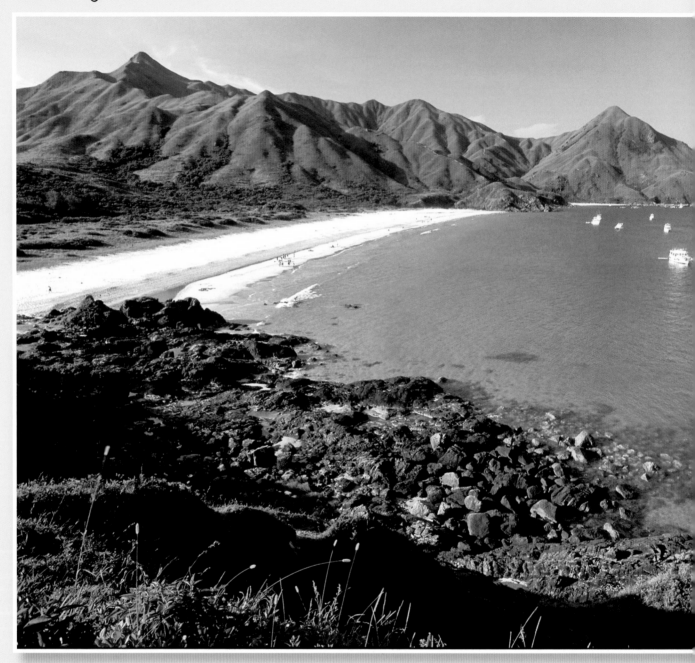

Above and top right: The Sai Kung Peninsula is wonderful hiking country, with a multitude of trails. The crown jewel of the peninsula – and one of the most beautiful places in Hong Kong – is Tai Long Wan (Big Wave Bay), on the peninsula's east coast. The bay is like a natural amphitheatre, with three sandy beaches bounded by rugged headlands and backed by abandoned fields and woods below an arc of hills. Trails lead over the hills to a hamlet with two small restaurants beside one of the beaches. Just north from the hamlet is the best beach, at Tai Wan, with no buildings in sight.

Below: In the southeast of the peninsula, the South China Sea has hewn cliffs of columnar-jointed rock, which also forms nearby islets. This rock, tuff, is the product of the cataclysmic collapse of a super-volcano some 140 million years ago. Violent explosions produced vast clouds of incandescent volcanic ash, which settled and became welded together. As the cooling rock contracted it cracked into hexagonal columns. This is the world's largest formation of columnar-jointed tuff, and is the star of the Hong Kong Geopark, which comprises eight areas in eastern Hong Kong, centred on the peninsula.

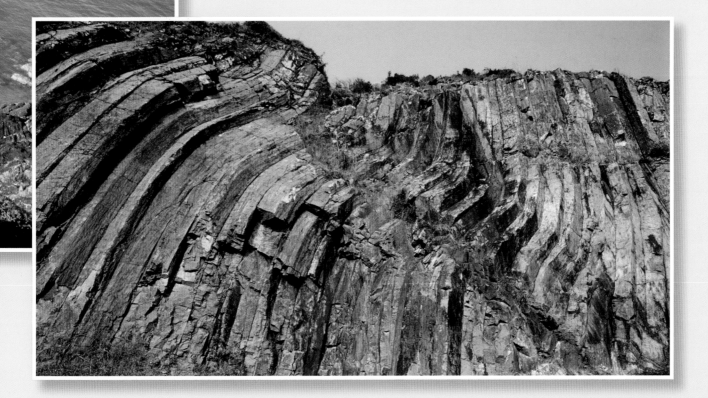

Northeast New Territories

The northeast New Territories is Hong Kong's wildest area. People have tried settling – clearing the original forests in the process – yet the hilly terrain has largely defeated farming and few villages proved viable. Today visitors can enjoy outstanding scenery and a tranquillity that may seem astonishing for somewhere in Hong Kong.

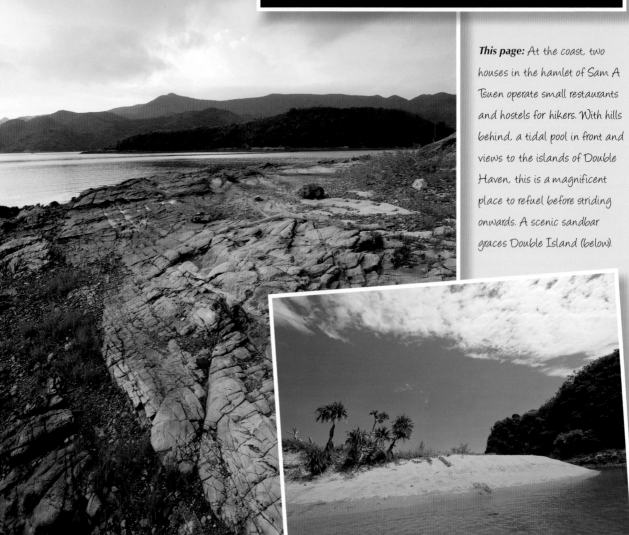

This page: *At the coast, two houses in the hamlet of Sam A Tsuen operate small restaurants and hostels for hikers. With hills behind, a tidal pool in front and views to the islands of Double Haven, this is a magnificent place to refuel before striding onwards. A scenic sandbar graces Double Island (below).*

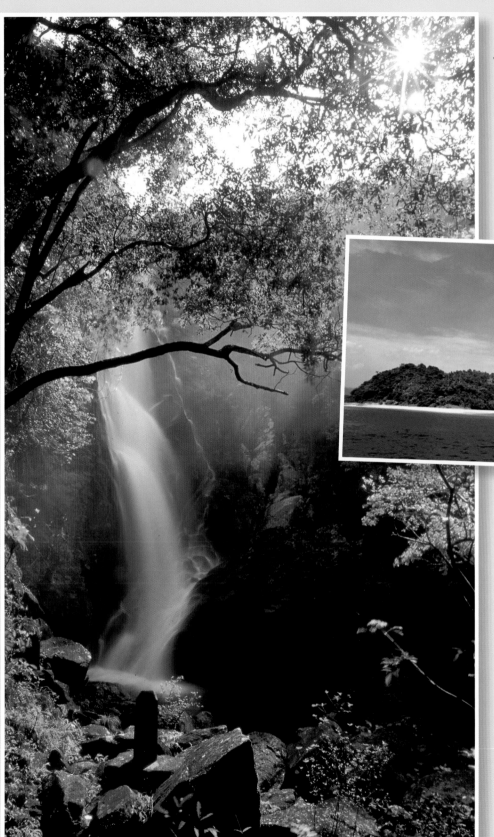

Left: The Mirror Pool Waterfall, just below Wu Kau Tang, is one of Hong Kong's finest and most accessible waterfalls. Nearby is the better known Bride's Pool Waterfall, named after a bride who – legend says – was being carried in a sedan chair and fell to her death in the ravine.

Above: Double Haven is a natural harbour, bounded by the indented mainland coast and an arc of three islands. Locally renowned for its beauty, its scenic attractions include oddly shaped islets, a channel lined by red rocks and this striking beach at the southwest tip of Crooked Island (Kat O).

Chapter 5: Lantau Island

The largest of Hong Kong's islands, Lantau, became home to so many temples that it was known as the Island of Prayer. Though developments have transformed the north coast, you can still enjoy tranquillity here.

Ngong Ping

Ngong Ping is a small upland basin on Lantau Island, where in 1906 three monks established a tiny temple that has since grown to become Po Lin Monastery.

Above: There's a steep trail to the summit of Lantau Peak, at 918 m (3,012 ft) the second highest mountain in Hong Kong. Alternatively, a gentle track leads north to a junction from which you might walk up to the Lei Lak Shan Country Trail – and curl round the hillside above Ngong Ping – or stroll along a concrete path leading back to the monastery.

Right: Other transformations of the area included the construction of a statue known as the Big Buddha.

Opposite: Feral cattle graze beneath the Ngong Ping 360 Cable Car that links Tung Chung and Ngong Ping.

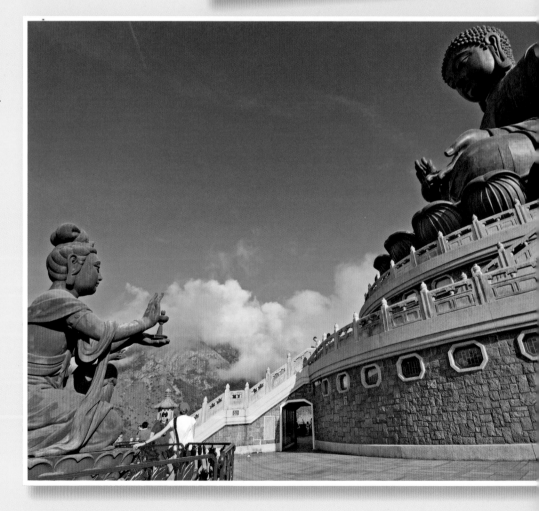

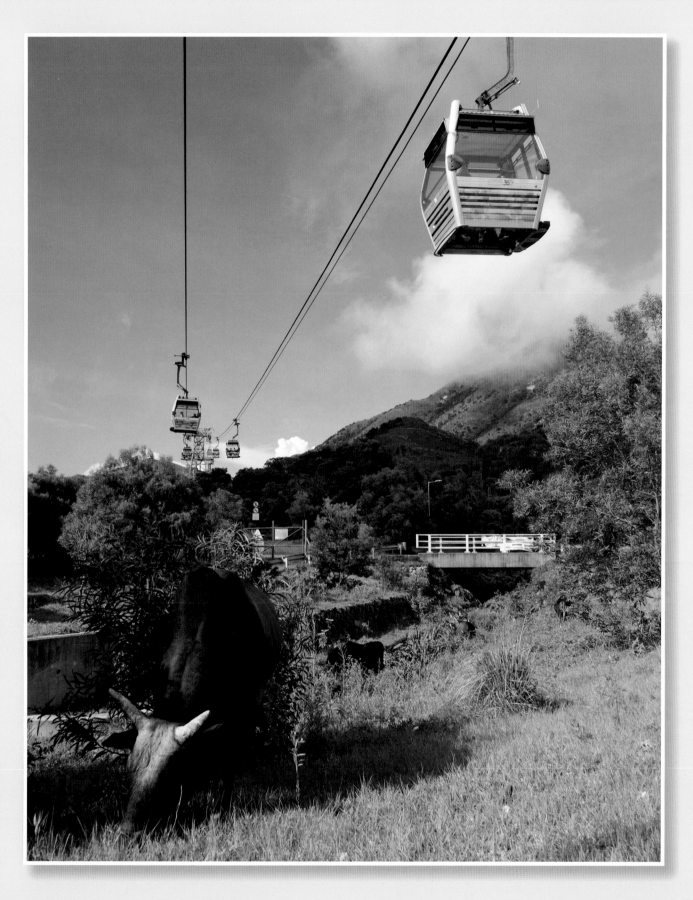

Tai O

These pages: *West of Ngong Ping, Kwun Yam Temple (right above) is one of the most beautiful in Hong Kong. It's set on a quiet hillside overlooking the west coast of Lantau and the village of Tai O.*

Tai O is well known for houses built on stilts alongside a tidal creek (opposite centre), as well as for dried seafood and shrimp paste made with salt that was formerly harvested on salt pans here. You can stroll the narrow, pedestrian streets past tightly packed houses beside and near the creek. There are seafood stalls (opposite above), two small museums and a handful of cafés. The offshore waters are home to the Chinese White Dolphin (opposite below) – one of only two pink dolphin species worldwide, which are best viewed on specialized dolphin watching tours.

Beside Tai O is a promenade alongside a lagoon with mangroves (right below). A coastal path heads further south, soon leaving the village behind. It makes for a pleasant walk to Yi O, a bay with a "hidden" waterfall close by a footbridge.

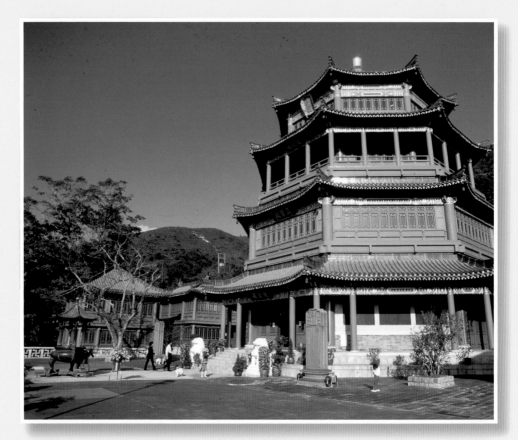

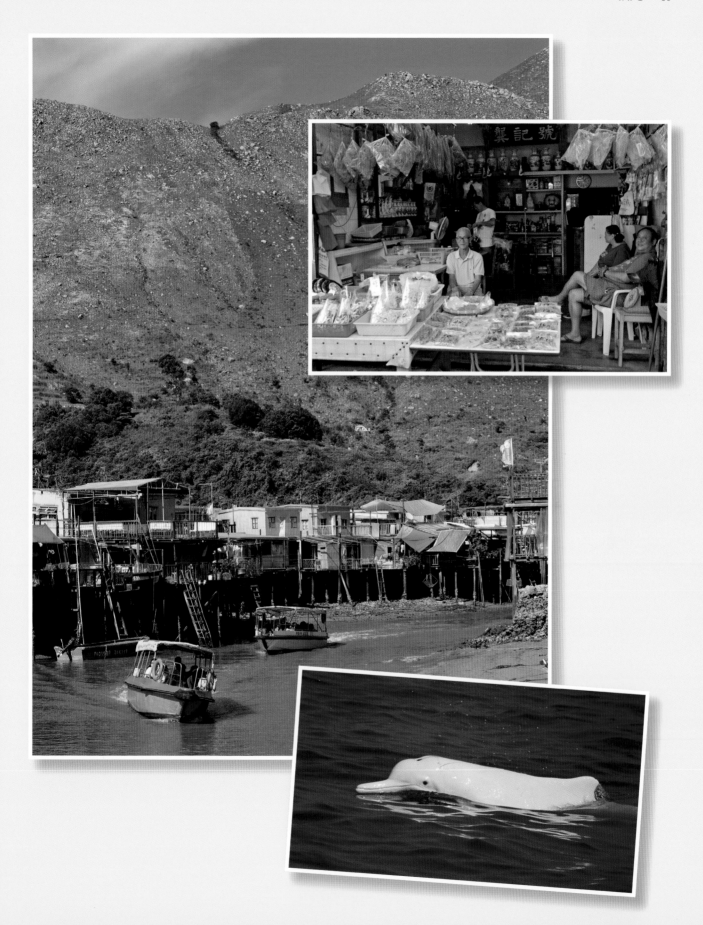

South Lantau

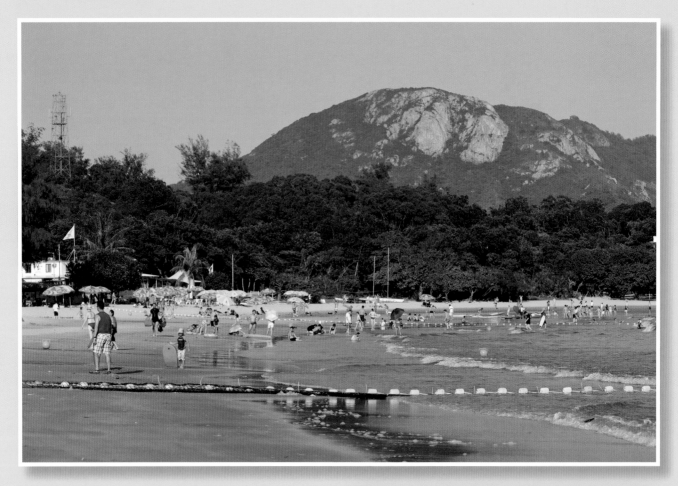

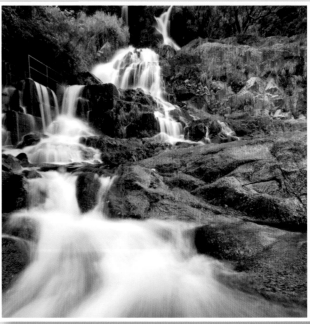

Above: Cheung Sha's name means Long Sands, after the almost two-kilometre (one and a quarter-mile) long beach that's interrupted only by a short bluff. It's a great beach for strolling along, enjoying views of mountains and sea. There are swimming areas with lifeguards, too – in the west at Upper Cheung Sha Beach and in the east at Lower Cheung Sha Beach, where there are also restaurants just above the tideline.

Right: Mui Wo, the main settlement in southeast Lantau – with a ferry service to Hong Kong Island – has also suffered from piecemeal rural development. Yet there are still paths through fields and by homes, and gentle tracks to the Silver Mine Waterfall, one of Hong Kong's best and most easily reached waterfalls.

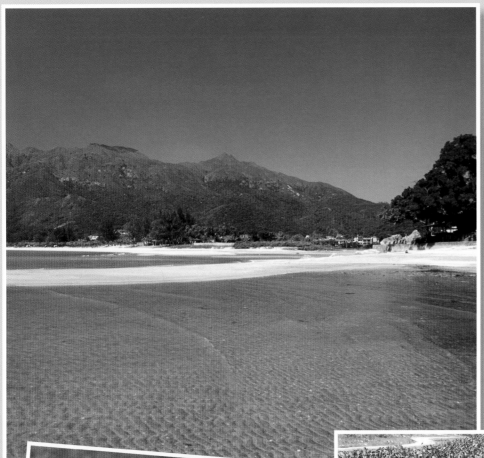

Left and below: Eastwards is another fine beach at Pui O, with gently sloping, fine sand and gorgeous vistas. Happily, fields separate the beach from the village, which is a ramshackle collection of modern houses. There are also paths through abandoned paddy fields that are now home to feral water buffalo. These are descendants of animals left to roam free as farming became uneconomic, and are well used to people walking by.

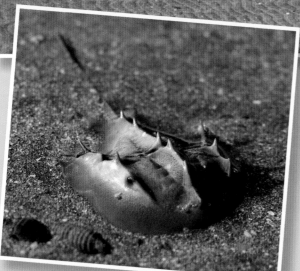

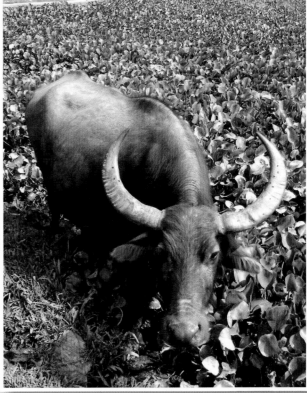

Above: At Shui Hau, below the south slopes of Lantau Peak, the falling tide exposes a wide expanse of fine silt, where you can find an abundance of shellfish as well as crabs including prehistoric looking young Horseshoe Crabs.

Chapter 6: Outlying Islands

Hong Kong's islands are mostly tiny and uninhabited, reached only by private boats. But you can ride public ferries out to a few of them and explore the rural communities and scenic landscapes.

Cheung Chau

Cheung Chau – Long Island – is small, easily overlooked on a map, yet makes for a rewarding excursion. Houses, shops and restaurants pack a narrow strip of land between two bays, with more housing along hillsides to north and south. Streets are narrow – the only car here is a police car and the main fire engines are souped-up quad bikes. Two beaches line the east shore, facing Hong Kong Island. Watersports include windsurfing; and an islander, Lee Lai-shan, shot to local stardom when she won gold for windsurfing in the 1996 Atlanta Olympics.

Above: As well as the beaches, streets and promenades, Cheung Chau has short but splendid coastal trails. One is fancifully called the Mini Great Wall and passes rocks with equally fanciful names, based on appearing like an elephant, a flower vase, a human head and even a zombie.

Right: The western bay has been partly enclosed by sea walls to guard against typhoons and form a harbour for a large fishing fleet.

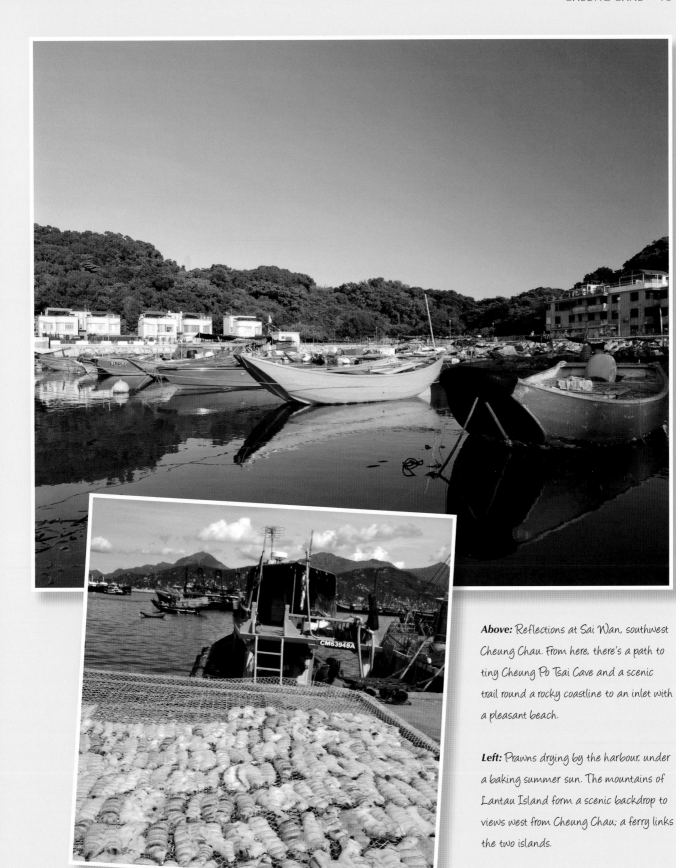

Above: Reflections at Sai Wan, southwest Cheung Chau. From here, there's a path to tiny Cheung Po Tsai Cave and a scenic trail round a rocky coastline to an inlet with a pleasant beach.

Left: Prawns drying by the harbour, under a baking summer sun. The mountains of Lantau Island form a scenic backdrop to views west from Cheung Chau; a ferry links the two islands.

Four Islands with Character

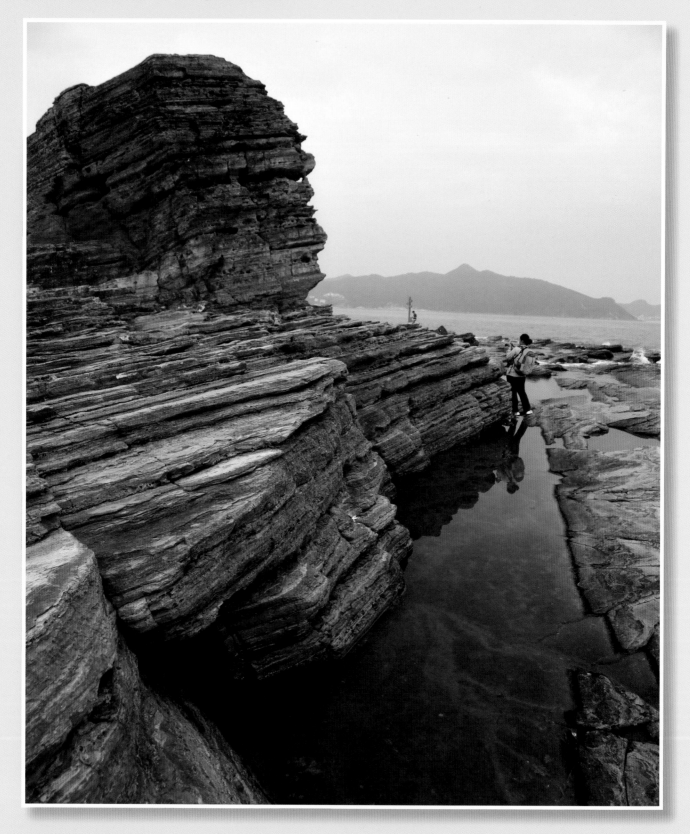

Opposite: In the northeast of Hong Kong, Tung Ping Chau is the territory's most far-flung land. Hamlets are all but abandoned but when holiday and weekend ferries run, some former residents return to open hostels and simple restaurants, serving people who come for gentle walks, views of mudstone cliffs and wave-carved platforms, as well as the chance to feel far from the city.

Left: Peng Chau lies close to eastern Lantau and is like a smaller cousin of Cheung Chau. The main street is just an alley lined with an array of small shops and restaurants. There's a coastal trail along the north coast, from which you can walk back to the village through a small valley with orchards and vegetable plots.

Above: Lamma Island has a somewhat unfair reputation as a hippie haven: westerners have moved here in search of quieter lives, but most commute to city jobs.

Left: South of Stanley lies Po Toi, mostly visited for its main seafood restaurant but it also has great paths affording grand views of granite cliffs and it's a hotspot for migrating birds.

Getting About

Hong Kong has an outstanding public transport system. This not only makes for convenient travel in the city, but in rural areas too – even relatively remote villages may have frequent minibus services.

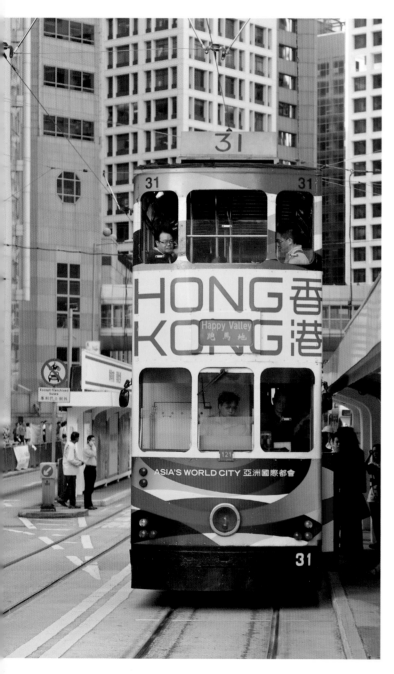

An Octopus stored value card is a boon for using public transport other than taxis. There's no need for change, as you simply put the card in front of an Octopus card reader and check for the beep as the fare is automatically deducted.

The rail network, operated by the MTR Corporation, has expanded in recent years. It may look confusing on maps but essentially there are key urban lines that are mainly subways serving north Hong Kong Island and Kowloon, together with two railway lines heading north – West Rail towards the northwest, and East Rail up through the central New Territories – and a route from Central to north Lantau. There are key interchange stations, where you can switch from one line to another.

While a rail journey could take you close to a destination, you might then take a bus, minibus or taxi to the exact location. Buses and minibuses abound, and though it can be baffling working out just where they're headed, some routes are popular with visitors – such as from Central to Stanley, and routes on Lantau.

Taxis are also readily found in most places. Red-painted taxis serve the main urban areas; green and blue taxis are cheaper, and operate in much of the New Territories and on Lantau Island, respectively.

Trams trundle along northern Hong Kong Island; they aren't too useful if you want to get somewhere fast but make for an enjoyable way of viewing the city.

Ferries ply a variety of routes, including to islands. Some are fast; others are slow, offering the chance to relax and watch the city recede into the distance as you head in search of island enchantments.

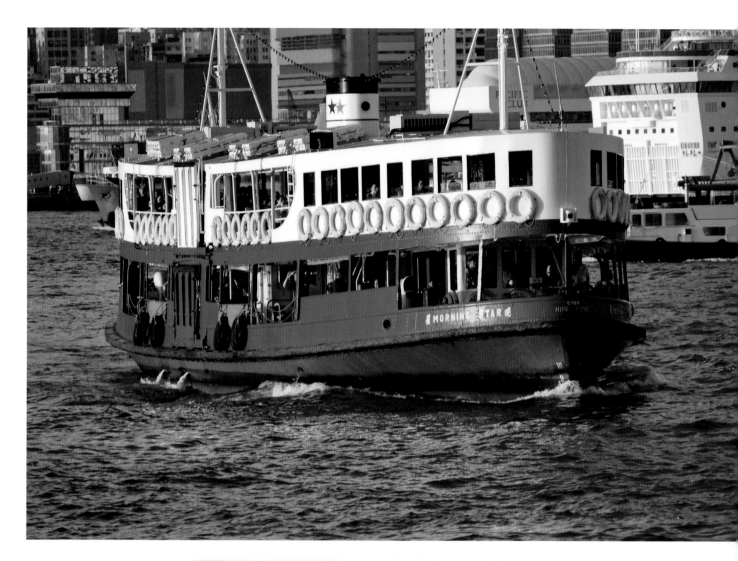

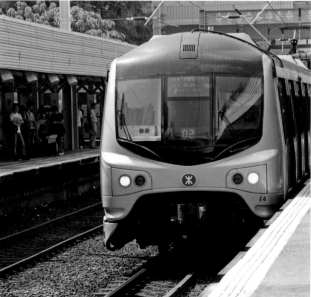

Above: The Star Ferry Company traces its origins to a steamboat service that began crossing the harbour in 1880 – with a vessel also named Morning Star.

Opposite: Hong Kong Tramways operates the world's largest fleet of double-decker tramcars. Ride on the upper deck for views of city life.

Left: Hong Kong's first railway opened in 1910, linking Kowloon and Guangzhou (Canton). The 1970s saw the advent of local, mass transit rail links, which have since spread through many urban areas. Today, Hong Kong's metro system, the MTR, carries an average of four million passengers each weekday.

Resources

Hong Kong Tourism Board

www.discoverhongkong.com – provides a wealth of information for visitors, with a bias towards shopping and dining in the city. There are also two city visitor centres, at the Tsim Sha Tsui Star Ferry Pier and the Peak Piazza.

Books

There are several travel guides to Hong Kong, placing strong emphasis on the city. Among the better ones are:
Lonely Planet Hong Kong & Macau, by Andrew Stone, Piera Chen and Chung Wah Chow (Lonely Planet, 2010); *Top 10 Hong Kong*, by Liam Fitzpatrick, Jason Gagliardi and Andrew Stone (DK Travel, 2011);
National Geographic Traveler: Hong Kong, by Phil Macdonald and Rory Boland (National Geographic, 2009); *Frommer's Hong Kong*, by Beth Reiber (Frommers, 2011).

One of the outstanding books on Hong Kong is the scholarly *A History of Hong Kong*, by Frank Welsh (Harper Collins, 2010 [reissued]).

Hiking guidebooks include *The Serious Hiker's Guide to Hong Kong* by Pete Spurrier (FormAsia, 2010). There are also books on special interests such as natural history, with titles including *The Birds of Hong Kong and South China* by Clive Viney, Karen Phillipps, and Lam Chiu Ying (Information Services Department, Government of the HKSAR).

Maps

The governmental Lands Department produces a series of Countryside Maps that are excellent for hiking:
Hong Kong Island & Neighbouring Islands,
Lantau Island & Neighbouring Islands,
North West New Territories,
North East & Central New Territories
and *Sai Kung & Clear Water Bay.*

Websites

The internet is a prime resource for finding up-to-date information on Hong Kong, including on places to eat and shop – though you may have to choose search terms carefully, and check that websites look reliable.

Sites worth visiting include:
www.hongkongextras.com – a rich source of information
www.hkoutdoors.com – founded by the author, it covers many aspects of Hong Kong outside the city.
www.enchantinghk.com – also founded by the author with information to complement this guidebook. If you have comments or queries, please post there or email martin@enchantinghk.com.

About the Author

Martin Williams is from Yorkshire, England, and moved to Hong Kong in 1987 after obtaining a PhD in Physical Chemistry from Cambridge University, and leading two bird migration surveys on the China coast. He's a freelance writer and photographer, widely published in magazines, and has written books including *Hong Kong Pathfinder*, a best-selling hiking guidebook. His passion for wildlife, especially birds, has led to his involvement in conservation efforts, such as promoting nature tourism. He is recognized as an Outstanding Earth Champion by the Earth Champions Foundation.